DETAILS OF THE WORLD

MFA PUBLICATIONS
a division of the
Museum of Fine Arts, Boston

SOPHIE RISTELHUEBER
DETAILS OF THE WORLD

TEXT BY
CHERYL BRUTVAN

DETAILS OF THE WORLD

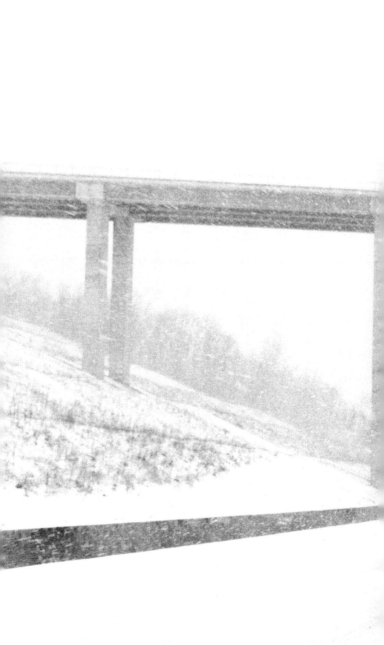

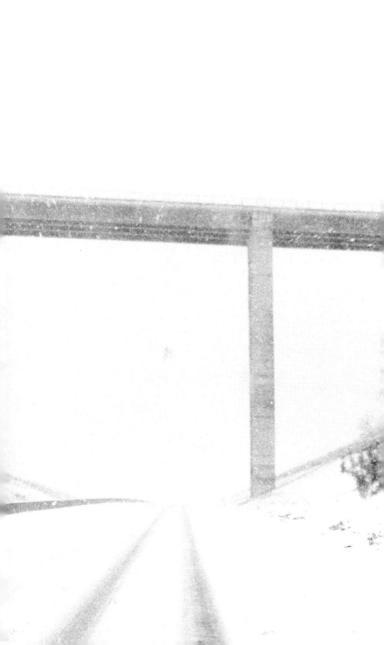

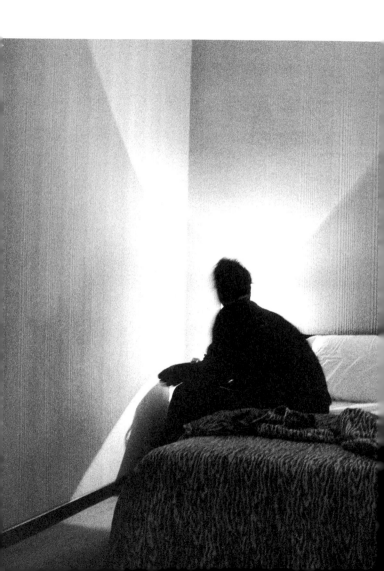

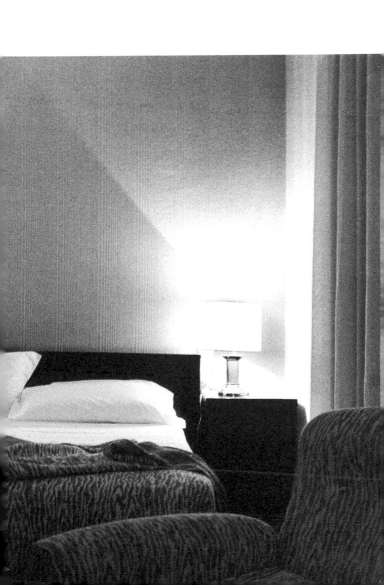

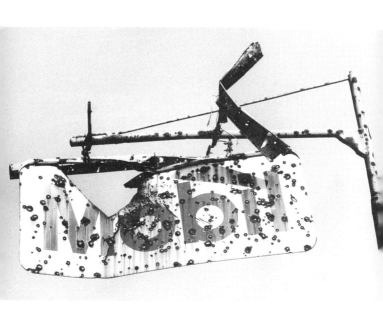

Beirut, Photographs, 1984

Sophie Ristelhueber's Obsessions

Despite her late arrival to making art, Sophie Ristelhueber has created some of the most moving work of the last century on the essence of our existence as individuals and as a civilization. As we decode DNA, discover new planets, overcome disease, and warily enter a new millennium, Ristelhueber reminds us that history repeats itself and that the golden rule "to do unto others as you would have done to you" seems enormously difficult to practice.

The compulsion to address such vast territory, strangely, results from the artist's personal obsessions—obsessions that are concerned with the most intimate evidence of direct contact, the result of a physical gesture: mark-making on a surface, whether our bodies or the earth. "I have these obsessions that I do not completely understand, with the deep mark, with the ruptured surface, with scars and traces, traces that human beings are leaving on the earth. It is not a comment on the environment...it is metaphysical... In a way, I am an artist standing a little like an

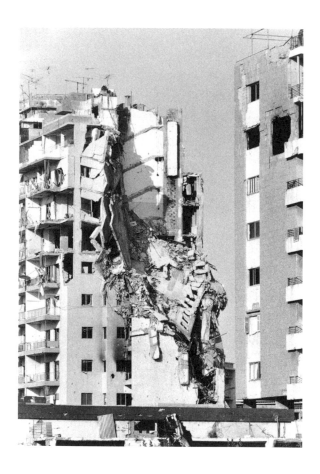

Beirut, Photographs, 1984

archeologist."[1] From this description, we might expect Ristelhueber to fabricate objects that depend on the artist's own gestures; instead, her explorations demand her use of photography to record what she has found. Ironically, her pictures are often ambiguous in their origin and indecipherable in their composition, yet these images are always the result of an immediate experience and are unaltered when finally reproduced. Her obsessions, however, have not led her to document the surrounding world as travelogue, nor to betray the gravity of horrific scenes of turmoil or personal suffering by arranging them into disturbing illustrations for the media. Rather, at the center of Ristelhueber's obsessions is a relentless struggle with "the question of representation [and] finally, the question of art itself,"[2] manifest in her belief that there is no greater reason to make art than to explore the world as it is.

How do we distinguish the boundaries (if they exist) between reality and fiction? And how does an artist suggest that such discoveries are of consequence? For Ristelhueber, the greatest truth is to be found in the details of the world.

Not satisfied with her immediate surroundings, she has gone out to face reality, journeying to locations whose names—Armenia, Beirut, Bosnia, Kuwait, Iraq—have become synonymous with civil war and man's inhumanity toward his neighbor. "The studio is not enough," she told a critic. "It is essential that I confront reality physically."[3] Through the image of an undefined landscape crippled by bombing, or even the peeling wallpaper in a family home, Ristelhueber transcends the turmoil and specificity of a location, and instead creates art without limits of time or identity. Most significantly, it is through the absence of life that Ristelhueber has so profoundly addressed life's fragile presence. It is through installations that cover walls and fill rooms—or, paradoxically, in the thoughtful assembly of her images in books that can be held in one hand—that Ristelhueber shares her own obsessions. These "threads of reality" (as the artist puts it) are primary evidence of the unceasing cycle of construction and destruction found in the surfaces of our world.

Ironically, it is a photograph notable for its ambiguity that embodies some of the funda-

Beirut, Photographs, 1984

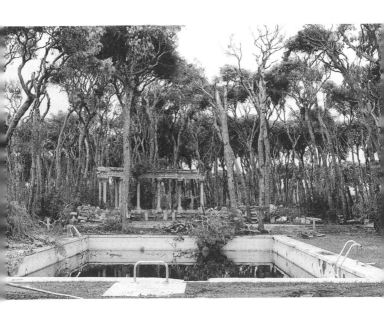

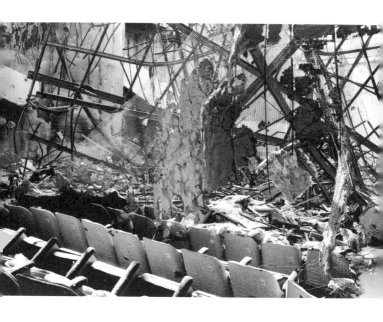

Beirut, Photographs, 1984

mental elements of Ristelhueber's obsessions. *Dust Breeding* (*Elevage de poussière*), taken by Man Ray for his friend Marcel Duchamp in the latter's New York studio in 1920, has remained etched in her memory since she first encountered it in the early 1980s. It appeared to be a landscape, albeit an inhospitable one; but, without readable scale, depth, or perspective, it struck her as incomprehensible. The only obvious elements within it were demarcations on a surface: a repetition of lines without obvious patterning, equally indecipherable if read as a detail or as an immense scene. As a photograph it was to be believed, yet it was filled with contradictions; revealing and mysterious; easily dismissed and fascinating. The image is in fact a detail of the surface of Duchamp's *The Bride Stripped Bare by Her Bachelors, Even* (1912–23; also known as the *Large Glass*), laden with dust accumulated over several months; yet, even this knowledge belies the power this rare image has to inspire decades after its creation. Its paradoxical nature would not only inspire a project, but also symbolize many of Ristelhueber's passions.

It is not surprising that Ristelhueber has adopted photography, a medium that we have historically associated with direct description and truth, as an essential element in her exploration of her obsessions. Yet she cannot be easily categorized as a photographer—and has even begun questioning whether photography can still serve her purposes as an artist. Nor, despite sometimes being mistaken for a photojournalist, does she have anything in common with them. "You do not have to abandon the terrain of the real and of collective emotions solely to reporters, editors, and photographers," she notes.[4]

Ristelhueber has no formal training in art, but instead was a serious student of literature in the early 1970s. More than anything, it is her examination of the French New Novel (*nouveau roman*) that infiltrates her approach to making art. Ristelhueber concentrated on the writings of Alain Robbe-Grillet, especially his novel *Jealousy* (1957). Robbe-Grillet and others developed in the late 1950s a startling version of writing fiction that challenged the traditional framework of prose and the expected development of narrative. Rather than through

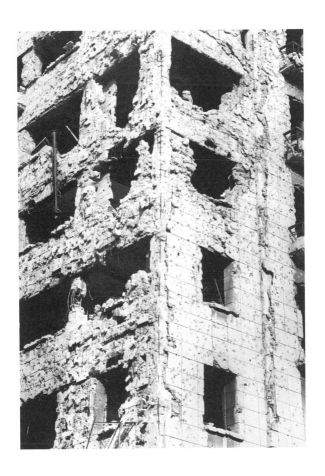

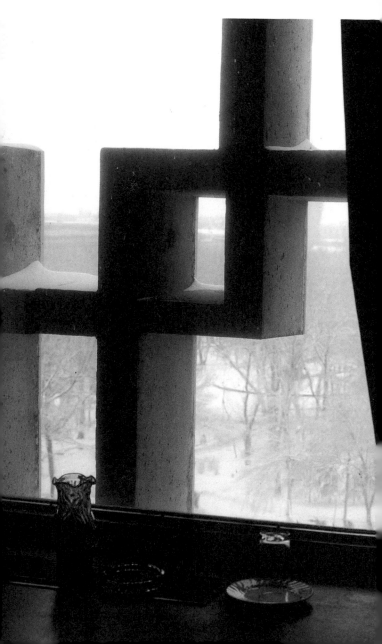

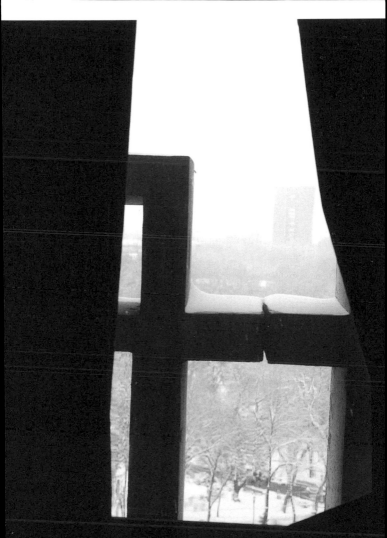

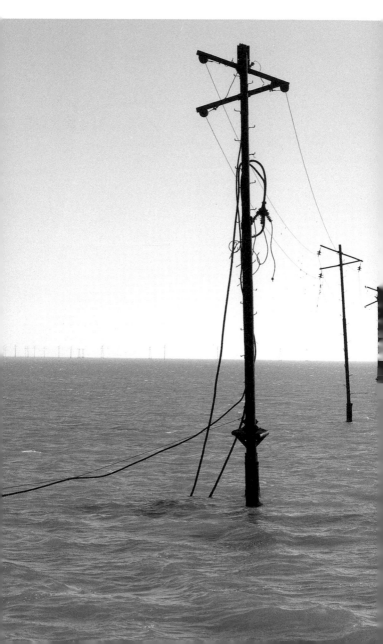

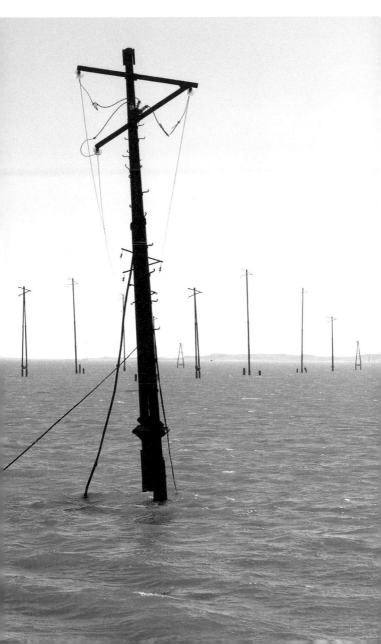

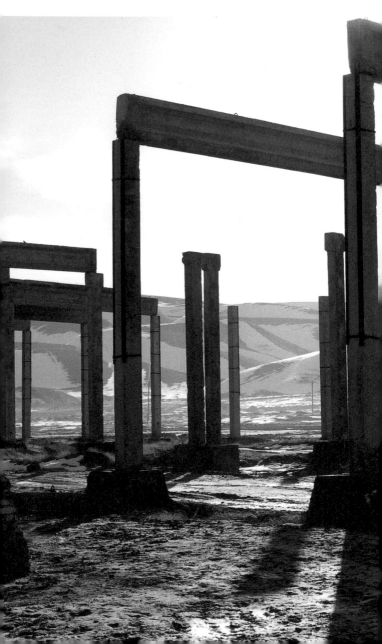

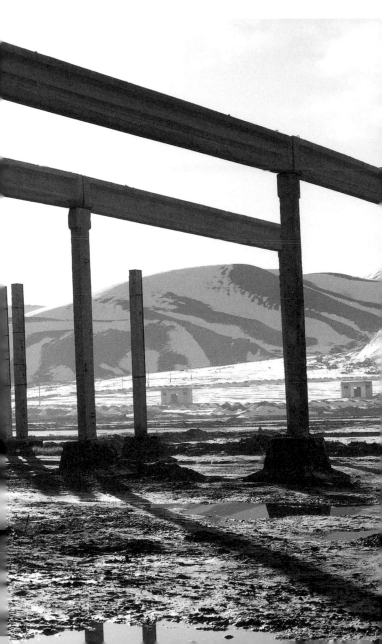

Every One (#1), 1994

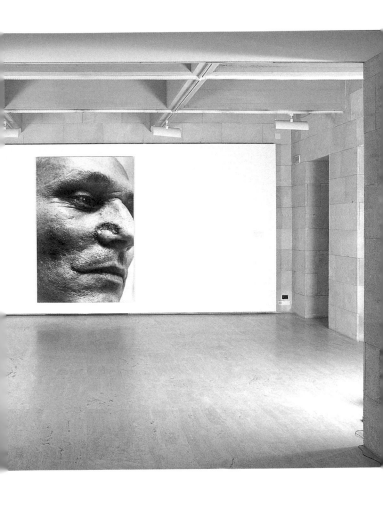

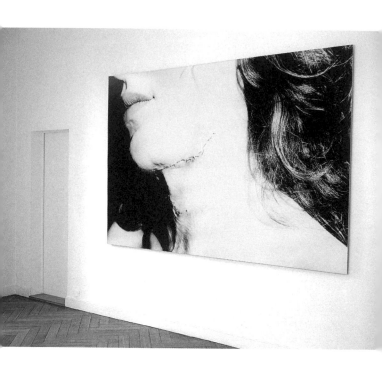

Every One (#5), 1994

metaphorical associations and descriptions that illuminate the author's world—internal or external—or a progression based on the traditional use of time, Robbe-Grillet emphasized extraordinary but objective detail. As defined by the author in his 1956 essay "A Future for the Novel," "the world is neither significant nor absurd. It *is*, quite simply. That, in any case, is the most remarkable thing about it."[5] Robbe-Grillet's purpose, summarizes the critic Roland Barthes, is

> to establish the novel on the surface: once you can set its inner nature, its "interiority," between parentheses, then objects in space, and the circulation of men among them, are promoted to the rank of subjects. The novel becomes man's direct experience of what surrounds him without his being able to shield himself with a psychology, a metaphysic, or a psychoanalytic method in his combat with the objective world he discovers. The novel is…of the earth—requiring that we no longer look at the world with the eyes of a confessor, of a doctor, or of God himself…but with

Every One (#14), 1994

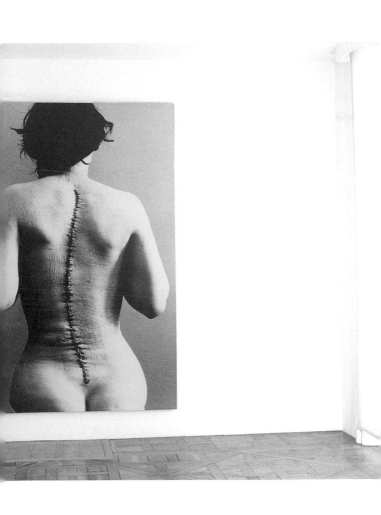

the eyes of a man walking in his city with no other horizon than the scene before him, no other power than that of his own eyes.[6]

There are strong parallels between Ristelhueber's work and the New Novel. The artist's obsessions with surface demarcations and her compulsion to physically seek out this evidence as a way of confronting reality take on greater meaning in the context of Robbe-Grillet's literary explorations. As Ristelhueber explains,

> Before I knew I would become an artist…I worked on Robbe-Grillet's novel *Jealousy*. As things are progressively, minutely described in this book, they cancel each other out. In the following chapter one finds the same story but slightly displaced, to such an extent that the previous story no longer exists. The precision of photography, what it maintains in the chosen frame, has something to do with the technique of the New Novel. Simultaneously, in my way of working, nothing is ever said; there is no story.[7]

Every One (#3), 1994

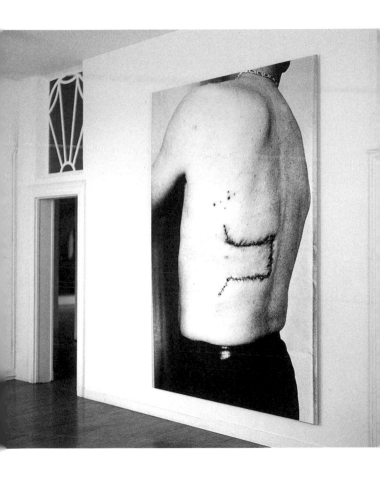

These ideas reinforce Ristelhueber's direction and even visually parallel some of her obsessions. In such projects as the critically acclaimed *Fait* and *La Campagne*, she created installations that reveal her paradoxical wish to disclose without leading the viewer, to provide a version of reality that is also a fiction, and to elicit in the person witnessing her work a desire to discern boundaries.

Following her academic studies, Ristelhueber earned a living by holding various publishing jobs. At *Zoom*, a visual arts magazine, she reviewed thousands of photographs on every possible subject, which substituted for a more formal training in the arts and gave her insight into the world of the media. In 1980 she was invited by the Belgian artist François Hers to write a text to accompany his photographs of public housing in Belgium. The proposal was daunting, bringing to her mind James Agee's moving tribute to rural America of the 1930s, *Let Us Now Praise Famous Men*, in which his words are beautifully integrated with Walker Evans's photographs. Ristelhueber soon realized the weakness of the written word compared with the

Every One (#8), 1994

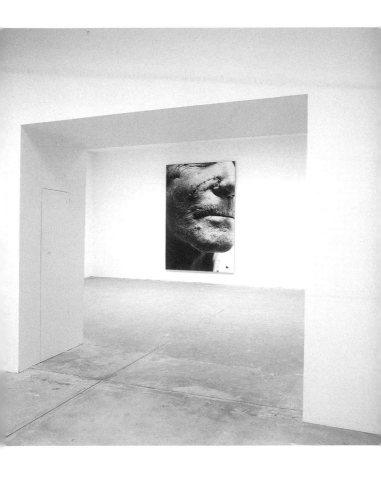

breadth of understanding afforded by images. For the Hers project, ultimately titled *Intérieurs* (1981), she determined actually to reside with her subjects, and photographed them in their homes near their favorite things, "swallowed by the flowers of the wallpaper and smashed by chandeliers."[8] These black-and-white photographs complemented color images of empty interior settings taken by Hers. The challenge she established in this early project still remains today: Can one document "reality" and make a piece of art at the same time? And whose version of "reality" is to be believed?

Another early exploration of these questions was realized through a series of black-and-white photographs, taken in a Paris hospital in 1982, which brought further to light the details and traces that would underlie later projects. Working among the medical staff in an operating theater, Ristelhueber created rich, painterly images in which she allowed only the stark light directed on the fragile and vulnerable human subject to illuminate her composition. The graphic nature of these images of isolated flesh waiting to be

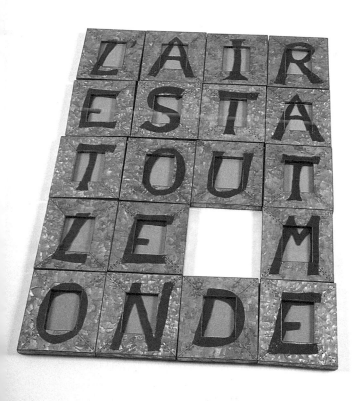

repaired, shrouded bodies, and patients with eyes closed can be quite unsettling and mysterious, as visitors to the 1982 Paris Biennale found:

> Surgeons shed their individuality behind their masks. I only dealt with their gestures. I also put on the "costume" of the operating theatre and my camera became just one among many instruments, just as familiar as those being used for the operation. My feelings were all the more profound and ambiguous because, in the way these bodies were handled, the flesh opens and blood flows. I was taking part in a ceremony that is highly codified, and where gestures consist of a blend of almost loving tenderness and violence.[9]

In Ristelhueber's case, her own sensitivity to the cyclical nature of inflicting harm in order to mend—and especially to a "sawtooth-shaped" scar around one woman's neck—continued to obsess her. It also partly inspired two installations of a decade later, *Fait* and *Every One*.

In November 1982, Ristelhueber determined to confront her obsessions with camera in hand.

She took upon herself a dangerous assignment to Beirut, a city whose name had become synonymous with civil war. "All I remember is that I followed very carefully the current events of that summer, not through TV but with daily newspapers and I got exasperated by the images, always the same: screaming mothers, preening soldiers, or militia men. And in the background, I was seeing the architecture in ruins."[10] She stayed in Beirut for two months, and along with the international forces replacing the Israelis, she set out to discover the city on foot. Ristelhueber had traveled with a clear purpose, to portray the familiar monuments of modern urban architecture in an unfamiliar state of ruin. She considered their pulverized, fractured surfaces with the same acuity as her structured encounter with human flesh months earlier. Using black-and-white film, she composed photographs of solitary structures, centered and viewed head on, or projecting into infinite space and including only enough information to allow their highly textured surfaces to be identified.

Significantly, Ristelhueber insisted that there be no sign of life in these photos; when neces-

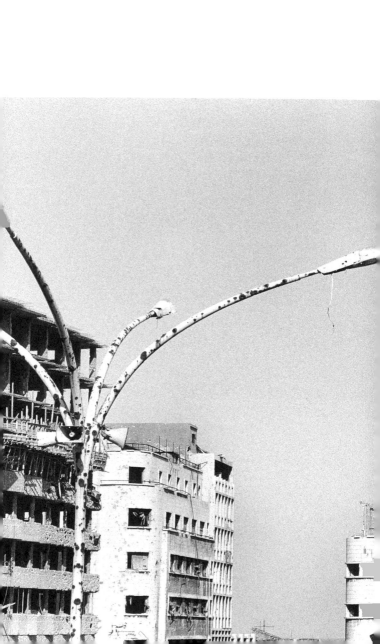

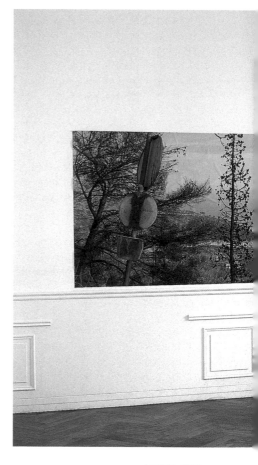

La Liste, 2000

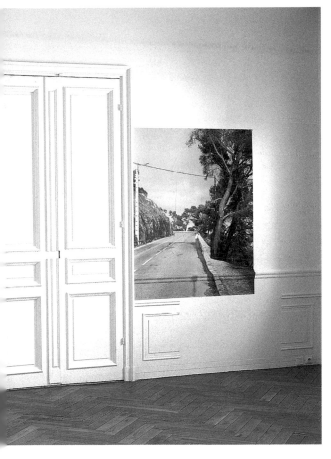

La Liste, 2000

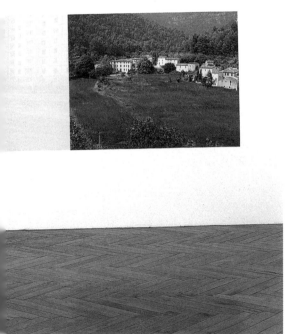

La Liste, 2000

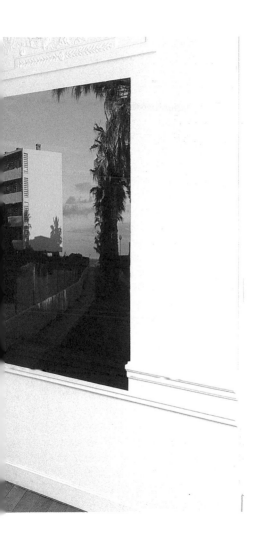

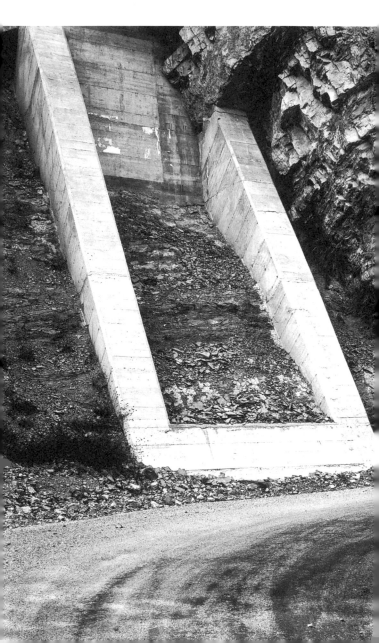

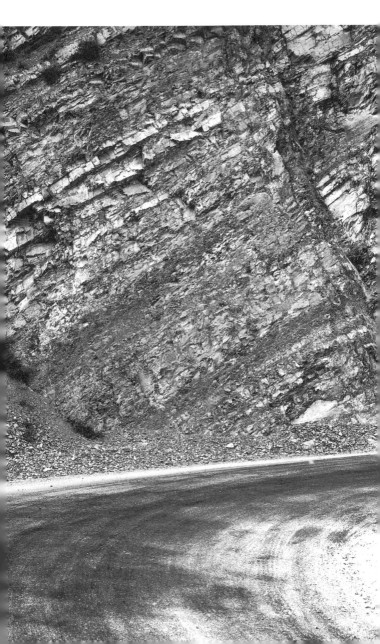

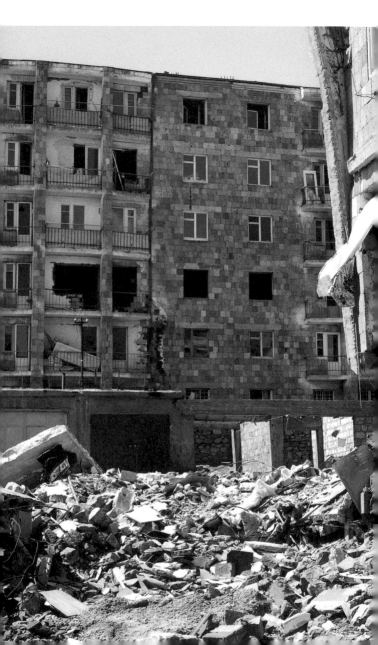

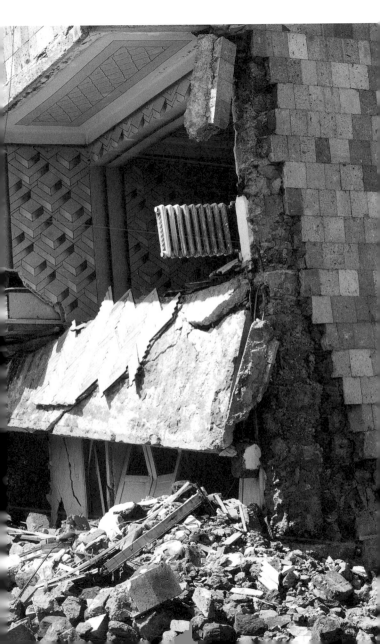

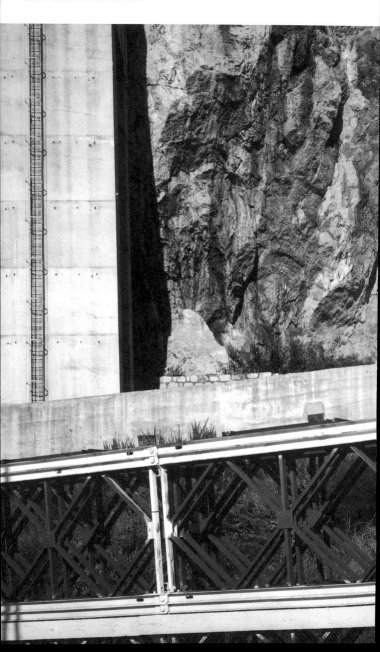

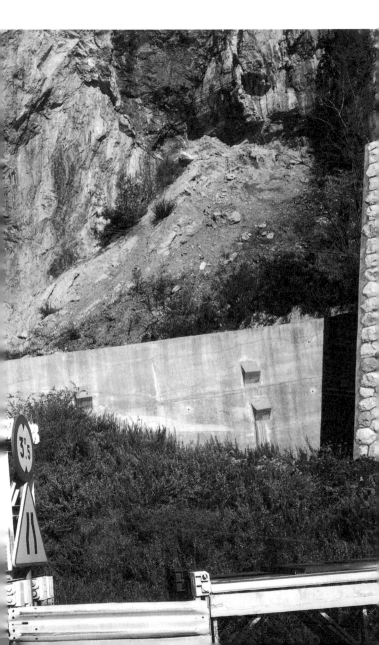

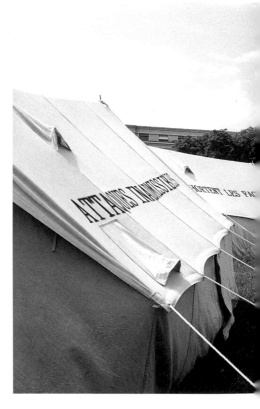

Resolutions (detail), 1995

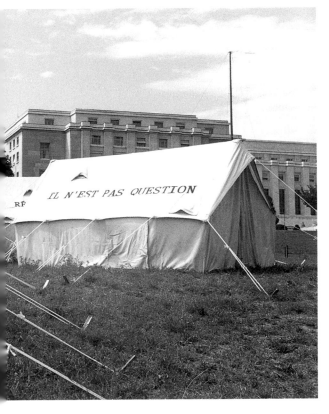

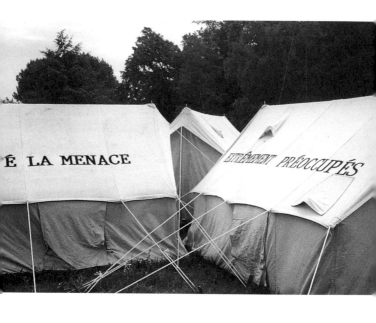

Resolutions (detail), 1995

sary, she struggled to keep people out of her frame. "When I think about it, of course I see myself as a little crazy…But I had a kind of absence from myself, absence from others, and I disrupted this by getting a very firm grip on reality."[11] Ristelhueber offers no story; there are no attributions or conclusions. Instead, she addresses the contradiction inherent in our attraction to the romance of ancient ruins versus our horror at comparable images deriving from contemporary reality. When these photographs were first published as a book (*Beirut, Photographs*, 1984), Ristelhueber was criticized by photographic reporters, who contested her decision to concentrate on buildings, "to look at a house as a house and to take this as my only subject."[12] The point of the Beirut project was not to create something sensational, but rather to make an eloquent statement through formal elements; to convey the disturbing essence of modern conflict without the expected scenes of conflict. Looking through the pages leaves the viewer stunned by the curious shapes formed by destroyed households and a sense of wonder that tons of concrete can be so malleable. Such

images of modern devastation have become sadly familiar, encouraging a sense of timelessness to *Beirut*. Through her careful placement of an opening image that includes the word "Jupiter" in an advertisement atop the shell of a multi-story building, to the last of the ruined Temple of Jupiter in Baalbek, Ristelhueber suggests her own shortened and wry version of history. It is a poignant acknowledgment that the dust from this conflict is only the most recent to settle "atop the layers and layers of the earth where Babylon lies below."[13] Instead of relying on her own words, she selected an excerpt from the ancient Roman philosopher Lucretius that revealed her own abiding interest in the significance of the traces left on the earth:

> We are loath to believe that a time of destruction and ruin lies in wait for the world. Even when we witness the tottering of mountains. And were the winds not to drop, no power could pull creation back from collapse. But in fact they die down and grow violent in turn, first rallying and then charging before being repulsed once again. And so catastrophe

threatens more often than it occurs; the earth buckles but recovers, and having toppled regains its balance. (*De Rerum Natura*)

Ristelhueber continued to face unfamiliar territories throughout the 1980s, including journeys to the Middle East, Tibet, and Armenia. Some of the images she took of her surroundings did not immediately become elements in artworks; some would not be assembled in projects until over a decade later, while others are reproduced for the first time in this book.

She was commissioned to travel to Armenia in the spring of 1989, following the devastating earthquake of the previous December. She found the swaying buildings barely standing, the piles of rubble and broken facades of majestic monuments all the more poignant after her immersion in *Beirut*—and in particular after finding the epigraph from *De Rerum Natura* cited above, which she first discovered at that time: "this precursory text made the link between my two encounters with destruction and disaster,"[14] she later said. But unlike *Beirut*,

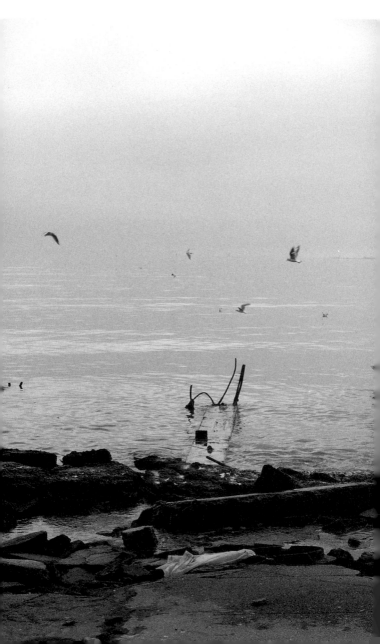

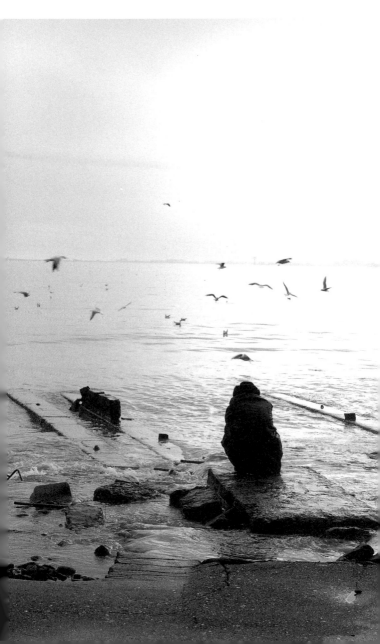

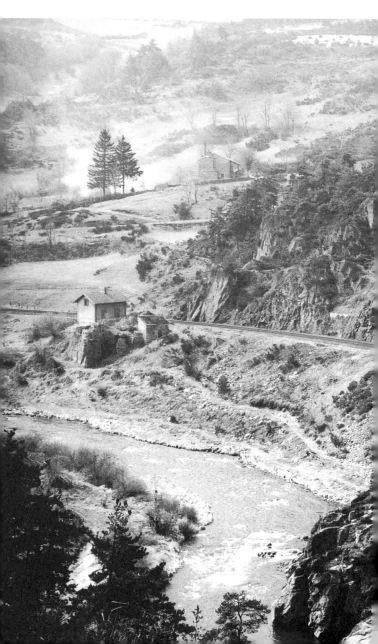

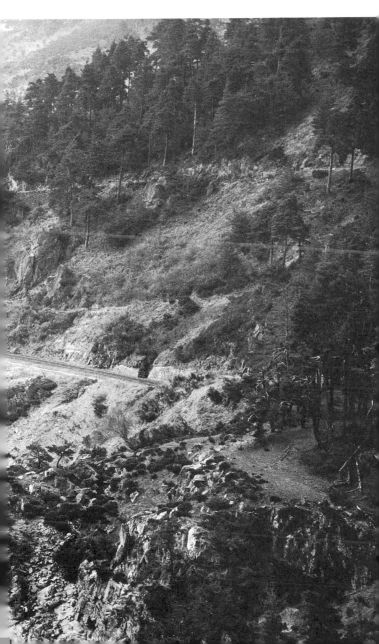

the Armenian compositions emphasize a horizontality more in keeping with traditional landscapes. Ristelhueber provides evidence of a surrounding, creating a context and the suggestion of perspective by relating the foreground and background to the horizon. There is a clear sense of the artist standing in place and revealing both her relationship to the scene and her position to the viewer.

The decade of the 1980s was also occupied by a commission from the French government organization DATAR (Délégation à l'Aménagement du Territoire et à l'Action Régionale). Ristelhueber was invited as one of twenty-nine photographers to document the landscape of her own country, a subject not accorded much importance at the time. The survey was concerned with the impact of national and regional development on the environment. Although Ristelhueber questions her association with landscape photography, this project allowed her to consider the intersection of her interests in ruins and traces within this grand tradition.

For this project, Ristelhueber concentrated on the Alps, and especially on the Alpes de Haute-

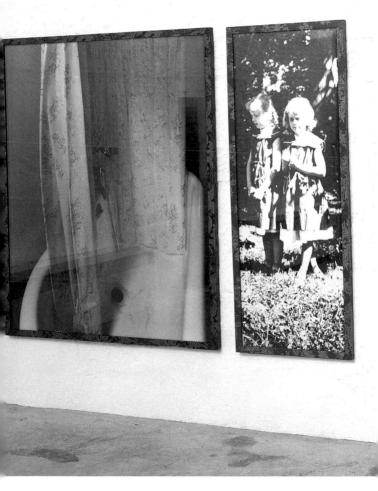

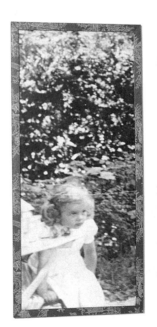

Vulaines III, 1989

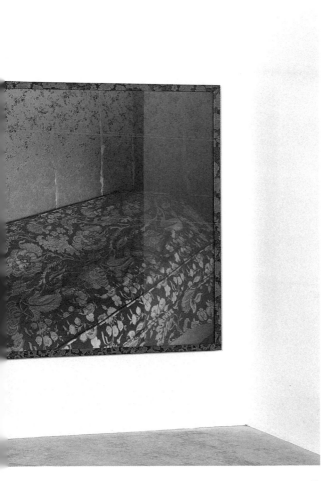

Provence, where layers of construction appear incidental as they crash into the more dominant, powerful forces of nature. To achieve her objective, she required the perspective of distance from less typical views that could only be obtained from the trains that run through the mountains. She emphasized the spectacle of extreme height and massive scale by the unexpected creation of remarkably shallow compositions. In contradiction to the strong verticality of the landscape, the plummeting views tend to flatten out the image (a format that would later prevail in *Fait*). The varied textures of irregular natural stone, uneven vegetation, and bridges and walls that intrude across this vast landscape become so much patterning in Ristelhueber's stunning images. She allowed the linear elements dating from earlier decades to infiltrate her frame and the jumbled conglomeration of structures incompatible with their natural surroundings to appear equally significant. Here, the scarred lines in human flesh seen in the operating theater are now transformed into borders, to provide access and conduct water as they wound the countryside. In this as in so

many other instances, Ristelhueber assumes the role of the artist as archeologist, unearthing her "fossilized France": "In nature, I was looking for materials and a situation that would allow me to maintain simultaneously the analytical distance of an anatomy lesson and a physical investment that made me feel, simply through the effort involved, that I was working concretely with this material."[15]

The DATAR project raises the question of Ristelhueber as landscape photographer, a characterization that she herself rejects: "I do not place myself in this tradition. I do not pay attention to perspective. I avoid the sky and focal points. I privilege saturated, compartmentalized spaces. The eye cannot fix itself to any path or cloud. There is no escape."[16] In these sophisticated compositions, one might conclude that Ristelhueber's objective is pure form. Yet her compulsion is to face reality, taking her to locations where she then avoids evidence of specificity in order to speak of the timelessness of our lives and our world through intentionally ambiguous or abstract images.

At the same time, these images are distinct

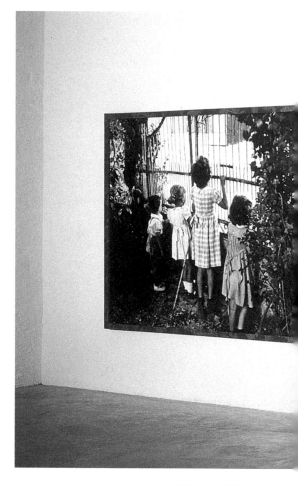

Vulaines I, 1989

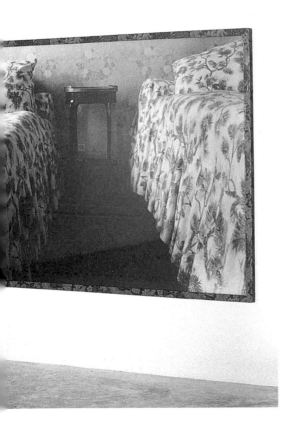

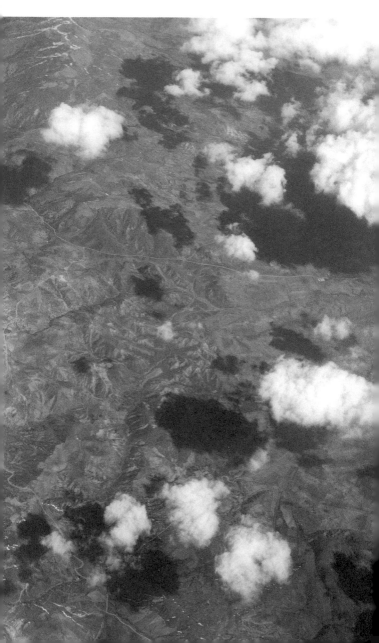

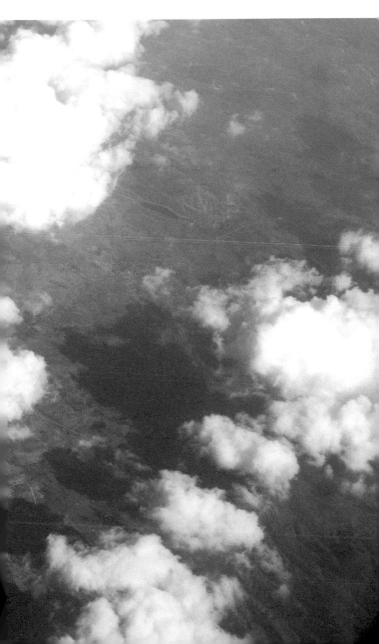

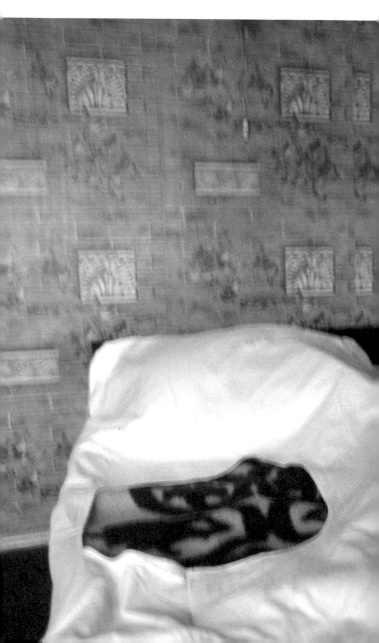

La Mission photographique de la DATAR, 1984

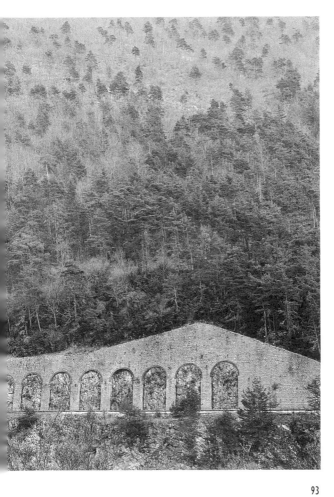

from the canon of formal abstraction and photography as exemplified by Harry Callahan, Lee Friedlander, or Andreas Gursky. The conceptual nature of her work acknowledges other tenets in the art of her peers. Yet she is opposed to engaging in art with reference only to itself and for its makers:

> Since the end of the major artistic and political engagements of the seventies, I think that artists have cut themselves off too much from society. Many work only in reference to art history or in reference to their own medium. I often find this result is depressing and vain. I think that my use of photography lies in recreating links between the world as it is and a potential work.[17]

Ristelhueber believes in the power of art and the need to consider the most serious issues of our existence as her subjects. Yet she is not interested in propaganda, capturing scenes that will tweak the public's emotions or reveal forbidden experiences; she is not susceptible to the illusion that her art will invoke political change. Perhaps,

La Mission photographique de la DATAR, 1984

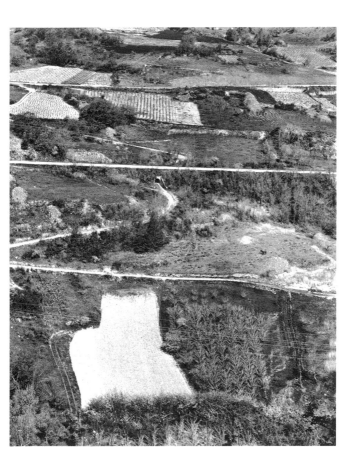

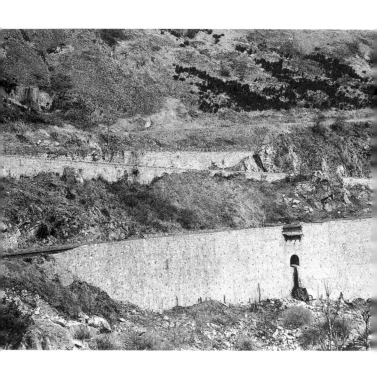

La Mission photographique de la DATAR, 1984

instead, landscape for Ristelhueber—its striations, folds, gashes, and traces—symbolizes a means to understand this moment in the grand scheme of things; landscape and its details reveal an effort to contextualize as well as provide a path for reflection.

As detailed and "objective" as the DATAR images were, Ristelhueber soon applied similar strategies to explore a more intimate reality: her own history. Suggesting one of the premises of the New Novel, that revelation is filled with fiction, she turned her eye on the familiar surfaces of her family's country home in Vulaines, a village south of Paris near Fontainebleau. At this comforting place that she still visits, she integrated the present reality of the worn upholstery, discolored wall paper, and dark wooden legs of a table with the memory of her childhood impressions. She did this by photographing from a child's perspective, closer to the floor, where only the details of an adult's surroundings are apparent. These color photographs were exhibited life size, and each was paired with an enlarged black-and-white detail from snapshots of Ristelhueber's

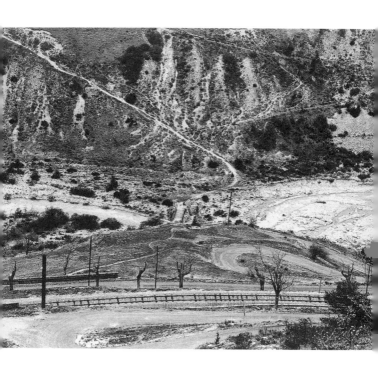

La Mission photographique de la DATAR, 1984

family when she and her sisters were children. The juxtapositions, and the cropping of the color images, allowed the edginess and tension of relationships and the discomfort of memories to be powerfully suggested. Poignantly, Ristelhueber cast her unflinching eye on the contradiction of memories—especially within one's own family—and the impossibility of realizing a self-description that will ever be accurate. A passage by Robbe-Grillet provides an apt description, "All at once the whole splendid construction collapses; opening our eyes unexpectedly, we have experienced, once too often, the shock of this stubborn reality we were pretending to have mastered. Around us, defying the noisy pack of our animistic or protective adjectives, things are there. Their surfaces are distinct and smooth, intact neither suspiciously brilliant nor transparent. All our literature has not yet succeeded in eroding their smallest corner, in flattening their slightest curve."[18]

The youngest of three daughters, Ristelhueber has a relationship within her family that is not unlike many: complex, continually reevaluated, and in stark contrast to her siblings. In the pho-

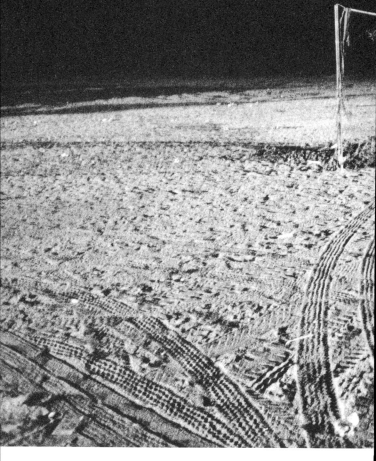

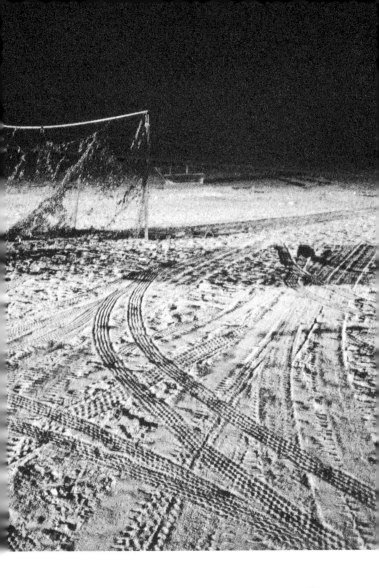

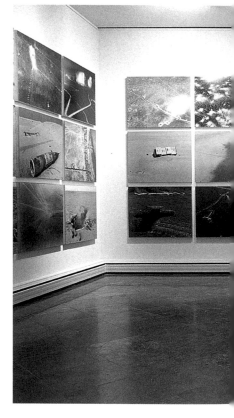

Fait, 1992

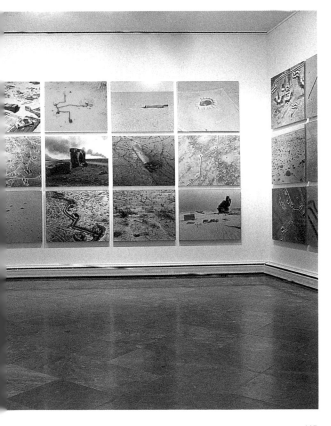

tographs of *Vulaines*, the power of a memory is found in a mattress that no longer holds its form but can only mirror the body that has used it for decades. The map created by the cracks on a plaster wall, exposed by peeling paint, reflects the traces of Ristelhueber's obsessions and, perhaps, the imagined world discovered through a child's loneliness. This time, the contradiction of exposing everything but never completely "knowing" is found not in crumbling ruins or mountains, but rather in the actual corners of her home. The details of *Vulaines*, more than in any other of Ristelhueber's works, suggest the unusual nature of interior description that dominates Robbe-Grillet's fiction. These domestic glimpses from *Jealousy* might even be said to describe Ristelhueber's own world: "The wood of the balustrade is smooth to the touch, when the fingers follow the direction of the grain and the tiny longitudinal cracks. A scaly zone comes next; then there is another smooth surface, but this time without lines of orientation and stipple here and there with slight roughnesses in the paint."[19]

When invited to exhibit in Geneva and create a book, Ristelhueber excluded the black-and-

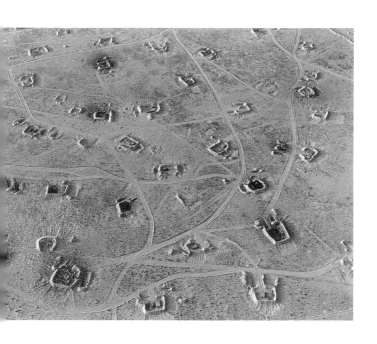

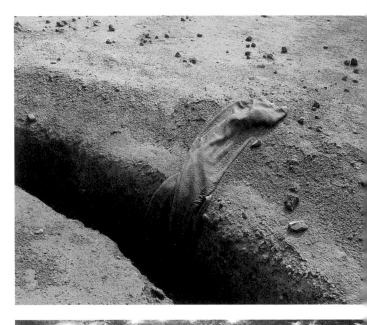

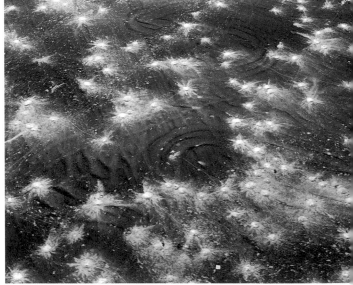

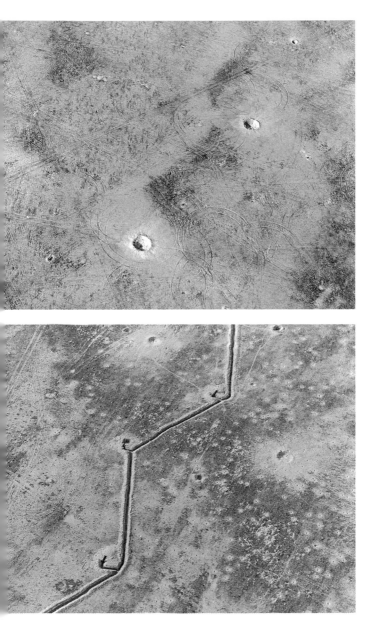

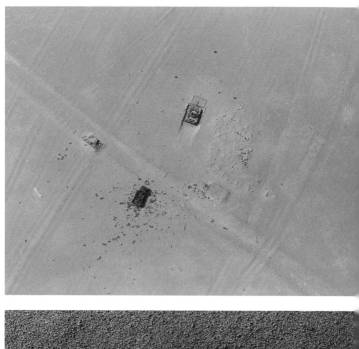

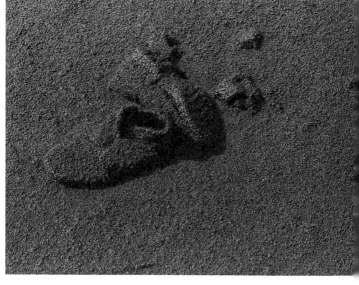

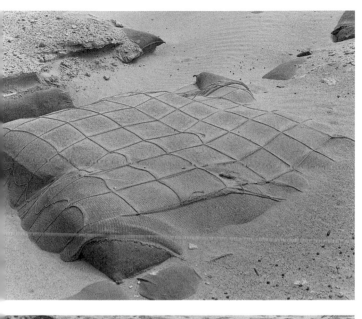

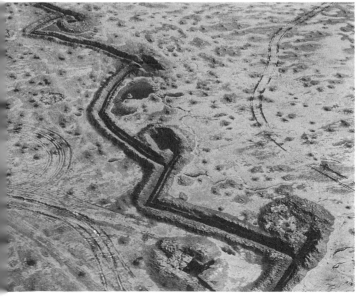

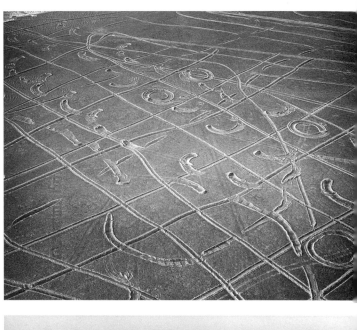

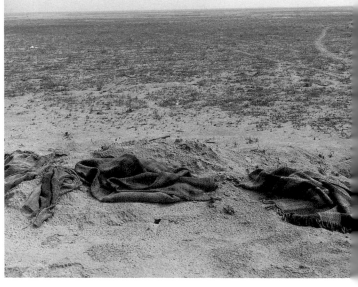

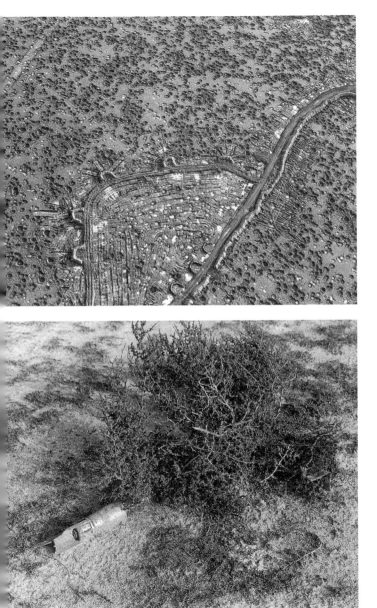

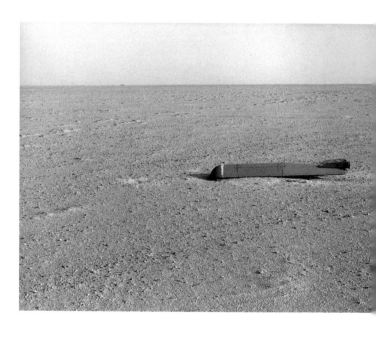

Fait, 1992

white details. She printed across the cover a passage from Laurence Sterne's eighteenth-century classic *The Life and Opinions of Tristram Shandy*, chosen for its ironic self-reflection:

> …nothing more would have been wanting, in order to have taken a man's character, but to have taken a chair and gone softly, as you would to a dioptrical bee-hive, and look'd in, — view'd the soul stark naked; — observed all her motions, — her machinations; — traced all her maggots from their first engendering to their crawling forth; — watched her loose in her frisks, her gambols, her capricios; and after some notice of her more solemn deportment, consequent upon such frisks, &c. — then taken your pen and ink and set down nothing but what you had seen, and could have sworn to…

The viewer of *Vulaines* must create his own version of reality, in this case from the intimate details of her family home; truth and fiction are regularly explored and at the heart of the photographer's approach to her art.

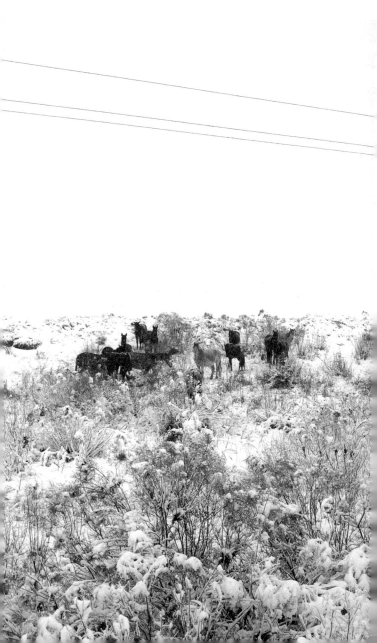

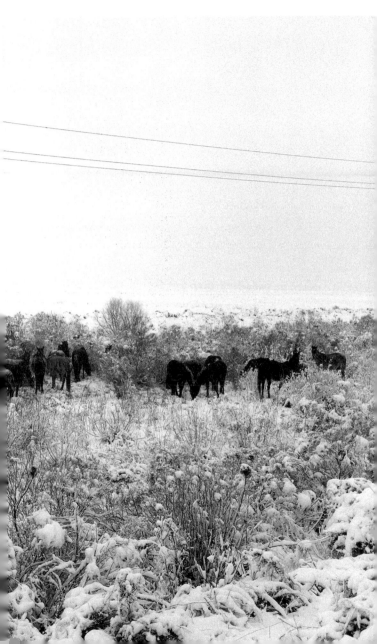

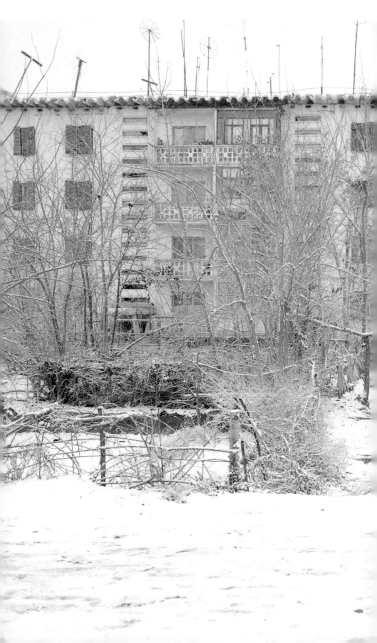

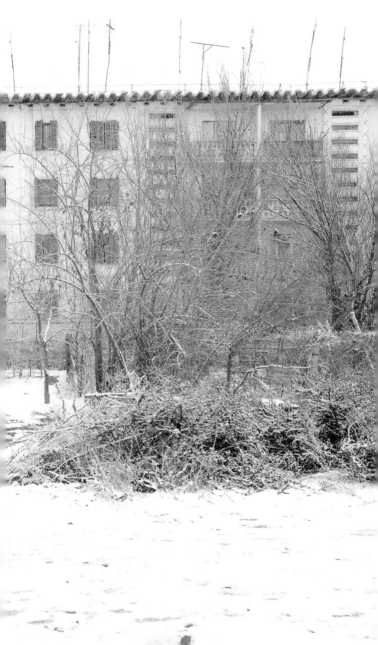

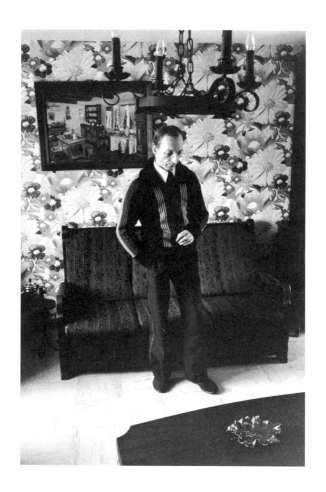

Intérieurs, 1981

While Ristelhueber has experimented with different technologies in the presentation of her images, from enlarging them to a scale of nine feet to printing them as flimsy, temporary posters, she does not manipulate the composition. She respects the circumstances in which she finds herself and all that precedes her decision to close her shutter. She relishes that the images she asserts are so often filled with contradictory messages. Yet her understanding of, and adherence to, "straight" photography could not be more ironic—even remarkable—at this point in the evolution of the photographic medium.

It is all the more astounding when one considers Ristelhueber's approach to the Persian Gulf War and the installation that resulted from it, *Fait* (1992), one of the most compelling artworks of modern times to address the violence of war and its unceasing appearance. More than with any previous conflict, the Gulf War was also a testament to government manipulation of the media. Previously, reporters expected (and often received) access to actual events; the immediacy and horror of the occurrence was an integral element of the reporting. In this case, as Ian Walker

notes in his essay "Desert Stories or Faith in Facts?" what Americans viewed as the half-time entertainment of the Super Bowl in January 1991 was the same image of the Gulf War as experienced by reporters. Nothing more was made available:

> In many ways, the journalists who were "there" were no more "there" than we were in front of our screens. They either sat in Saudi Arabia, attending press conferences being shown precision hits by smart bombs, or they sat on ships in the Gulf watching the Cruise missiles being fired, or they stood on their hotel balcony in Baghdad watching those missiles come down the street and turn left at the traffic lights…In other words, they could not get at the war…This was a new type of war…The most potent images were those taken by the military themselves.[20]

The last decade of the twentieth century has seen the acceleration of "spin control" and crazed attention to even minor events by a media desperate for ratings; an attempt to offer "news"

Intérieurs, 1981

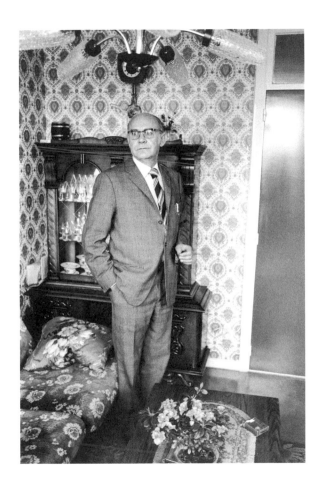

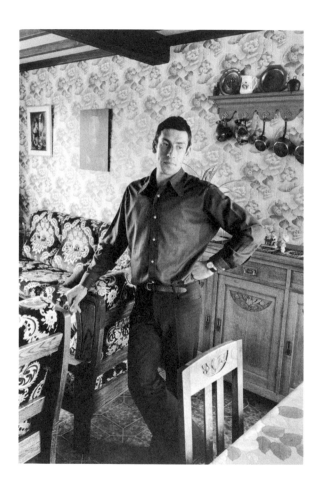

Intérieurs, 1981

as entertainment. At the same time, technology has also allowed ever more sophisticated possibilities of manipulating images, seamlessly and believably. More than ever, as Walker suggests, one must now question our reliance on visual images as truthful or factual— a concept Ristelhueber has challenged in all her work. What she has created here is not only a powerful testament to the cyclical nature of violence and destruction, but also one that remains independent of the highly controlled arena dedicated to the Gulf War.

Fait was provoked by a photograph in the February 25, 1991, issue of *Time* magazine, a small monochromatic image, apparently an aerial view above the Kuwait desert. Without the help of the accompanying article, it could be interpreted as an abstract image of black blooms above a scarred surface. For Ristelhueber, it immediately brought to mind Duchamp's *Dust Breeding*, which had been burned into her memory. The combination of visual references and her consistent interest in traces and ruptures reached its peak. "I was obsessed by the notion of a desert that had ceased to be a desert,"[21] she later said. Recognizing that such wounds on the earth's sur-

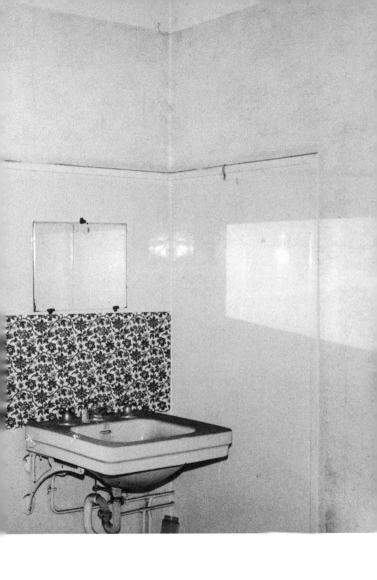

131

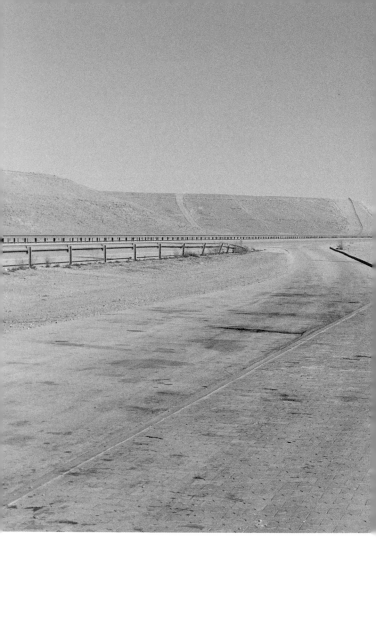

face would soon disappear with the wind, she began the long process of gaining approval to travel to Kuwait. Ristelhueber's preparations for this project were extensive, costly, and thorough; they would also place her safety in jeopardy. Her stay in Kuwait lasted only four weeks, as opposed to the months she would spend in the studio following her return; yet this short amount of time bespeaks the certainty of her mission.

Distinguishing herself as an artist from the remaining journalists, Ristelhueber arrived in October 1991, seven months after war had ended. Although she was first considered with indifference or to be a fool, her early morning departures and access to difficult locations eventually brought respect and a degree of suspicion from those still assigned to the location. Rides in helicopters or planes—necessary for the views she wanted to capture—were unpredictable and difficult to negotiate. Having virtually no experience with an aerial vantage point, she brought a heavy camera to help minimize the distortion and inevitable blurring that would result from hanging out of the aircraft door as she quickly composed her frame and shot. "It was as if I

were fifty centimeters from my subject, like in an operating theater. I was so sure about what I wanted to do."[22] For most of *Fait*, Ristelhueber used color film, allowing the natural mono-chrome of the desert sand to limit her palette, though she adopted black-and-white when the smoke from the burning oil fields made every-thing appear to be shades of gray, even when the sun was at its highest.

In addition to flying precariously above the desert, Ristelhueber insisted on walking on the hot, unforgiving terrain among the trenches, tank tracks, piles of personal belongings, shell casings, and land mines. She needed not only to find her ruptured, abstract surfaces from above, but also to locate the humanity within such vio-lence. As in Beirut, it was through the obvious absence of life that she affirmed the weight of its presence:

> I found a collection of shaving brushes, razors, and little mirrors that must have formed part of the soldiers' kits. There were personal diaries and tartan blankets like those of my childhood. I got the feeling I could

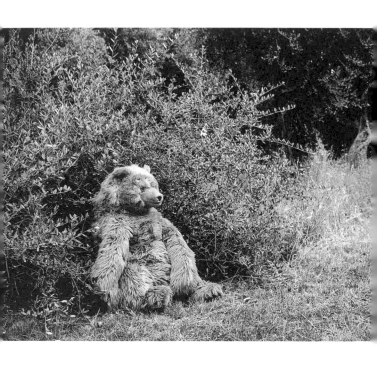

Les Ours d'Hartung, 2000

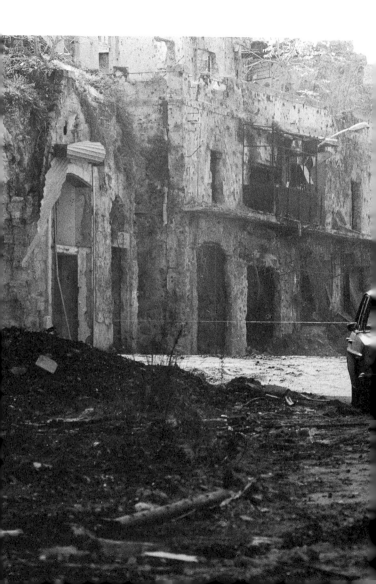

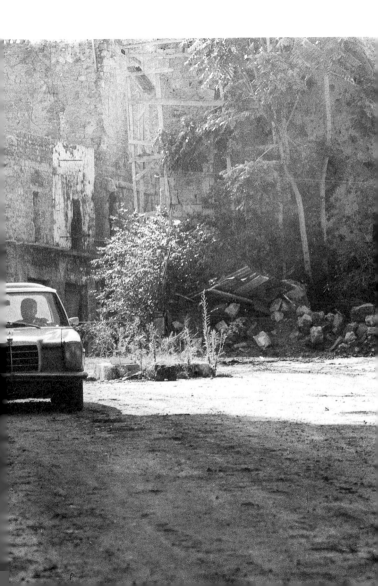

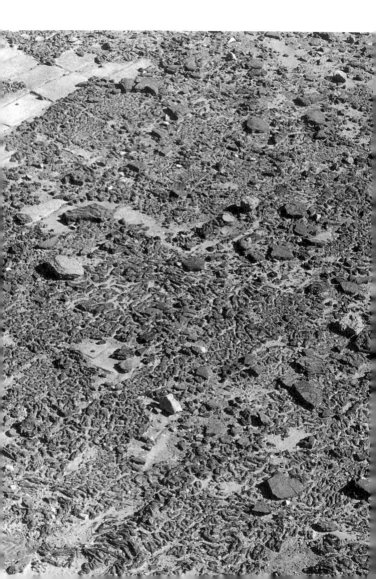

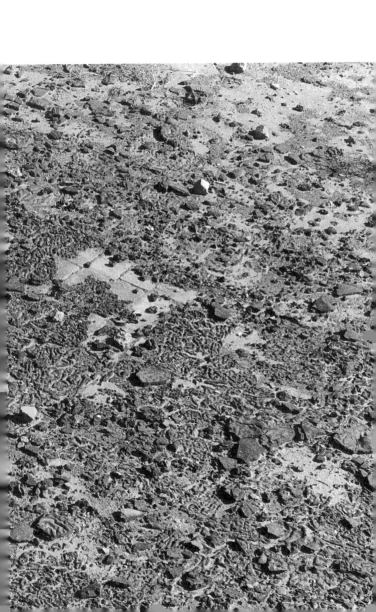

Les Barricades mystérieuses, 1995

physically sense the soldiers' crazed flight
northwards. I was deeply disturbed by this
twofold abandon of both man and object.
Such "still lifes" highlight the prosaic side of
warfare. At the same time, once divorced
from their purposes, objects too become
abstractions."[23]

The paradox of the technological sophistica-
tion that created the battered surface of the
now-quiet land Ristelhueber explored has been
sadly recognized for generations by those who
address the inhumanity of war through photog-
raphy. Over a century earlier in the United
States, the great landscape photographer Timo-
thy O'Sullivan, before taking his remarkable
photos of the unexplored West, first earned his
reputation for his images of the aftermath of
modern warfare on the battlefields of the Civil
War. To reveal the sophistication of the new
technology, he concentrated on its effects, left
strewn across the terrain. More recently, the pro-
found loss of life and, perhaps, of a nation's con-
fidence was poignantly acknowledged in the
metaphor of a wound or scar by artist Maya Lin

in her concept for the Vietnam Memorial in Washington, D.C. Ristelhueber's choice of title for the project—which translates as both "fact" and "what has been done"—again illustrates the artist's keen awareness of the prevalence of contradictory meanings. "I needed a laconic title…What I saw—the war—is a fact. The forms I was able to grasp were 'facts' of war, then they were my facts. The war, and its forms, do not express more than 'That's the way it is.'"[24] When finished, *Fait* totaled seventy-one images; it was exhibited at Le Magasin in Grenoble and printed as a small book. At the beginning and end of the reproductions, Ristelhueber placed two texts, excerpted from Karl von Clausewitz's nineteenth-century manual *On War*. In contrast to the intimate format of the publication, she also printed the negatives at 40 x 50 inches each, installed so as to surround the viewer and approximate the artist's physical relationship with her subject. Ristelhueber arranged her images in careful rows to form a grid, configured according to the exhibition space, attending to the juxtaposition of each image: *Fait* is as much a physical experience as an intellectual and emo-

Les Barricades mystérieuses, 1995

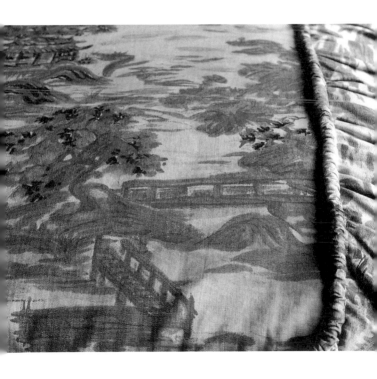

Les Barricades mystérieuses, 1995

tional one. Enveloped by the shifting planes, confused by the absence of recognizable scale and loss of perspective in these intentionally abstract details, the viewer is left to his own conclusions, and even with a sense of vertigo. Abstract and referential at the same time, *Fait* is one of the few believable works resulting from this most recent battle in this part of the world, one of the cradles of civilization.

For Ristelhueber, *Fait* was not only about the meanings derived from her obsessions with ruptured surfaces; the details in her compositions also spoke of how we see things. The torn desert viewed from above reminded her not only of *Dust Breeding*, but also of the "sawtoothed" scar on a woman's neck seen in a Paris hospital ten years earlier. And the forbidden view of Iraq, pointed out by one of her pilots when entering the "no fly zone" near al-Basrah, in the south where the Tigris and Euphrates rivers merge before emptying into the Persian Gulf, became a new obsession that she would not explore for another decade.

While critically acclaimed for its ability to speak of the devastation of war, *Fait* was most

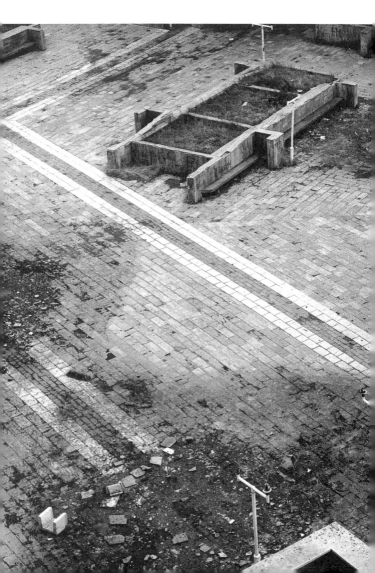

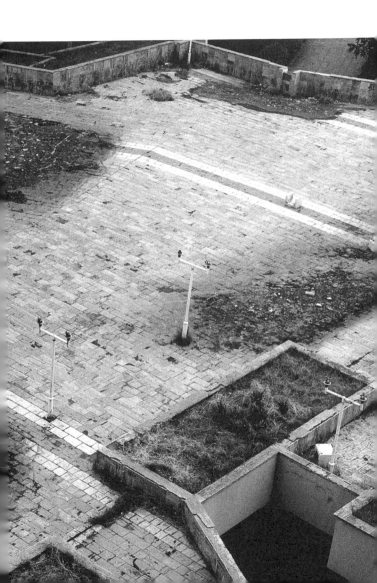

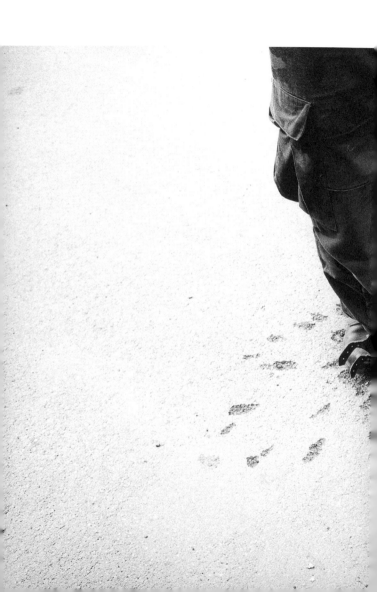

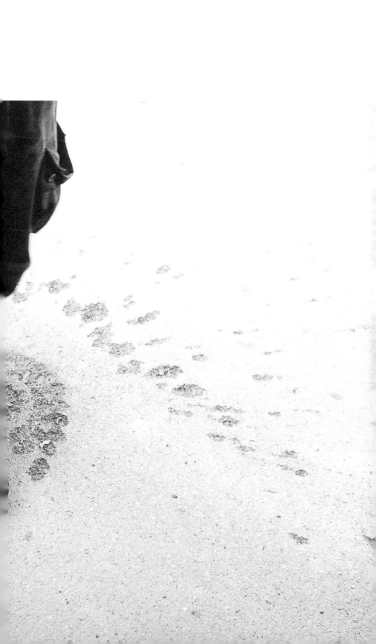

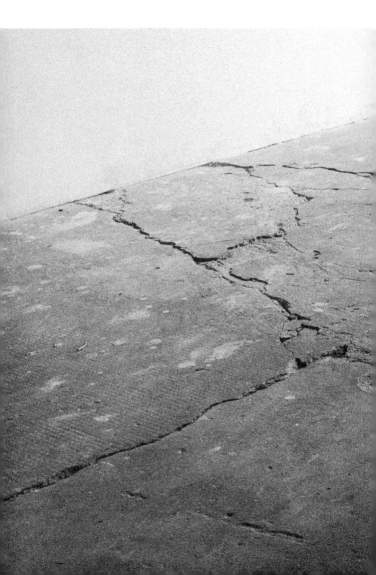

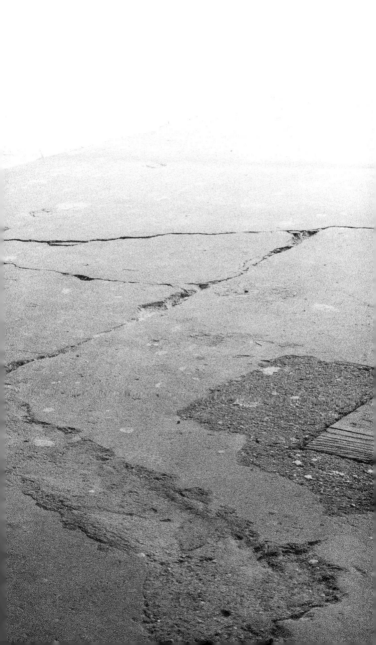

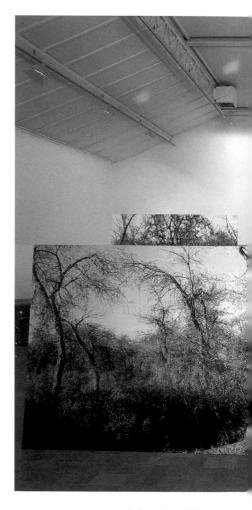

Autoportrait, 1999

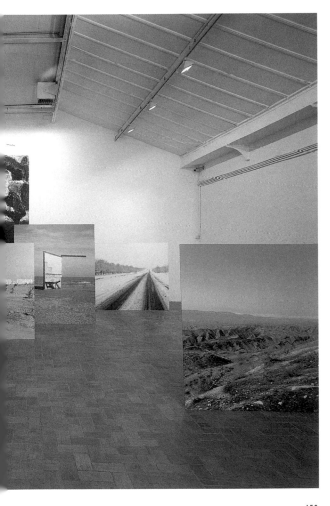

satisfying to the artist as a work that addresses our difficulty in determining what we see and the reasons behind our interpretation. That this work carried meaning beyond the immediate circumstances of its origin was confirmation that she had realized her objective, a concept that has also been essential in the projects that followed.

Ristelhueber first journeyed to Yugoslavia in July 1991, disturbed by the appalling reports of atrocities between Serbs and Croats, to serve as driver for her journalist friend Jean Rolin. Her intent was not "to create a testimonial or bring back even more photos of current events, but merely to feed my own work and to see."[25] As she would several months later in Kuwait, she experienced a chill on this trip from Belgrade to Vukovar, facing the remnants of fabric, furniture, and belongings that had once comprised a home, now thrown out as if vomited from their interiors. They represented not only lost life but also the brutality permeating the silence. She was angered by what she saw as Europe's cowardice in dealing with this area so close to its own borders, where unspeakable acts were

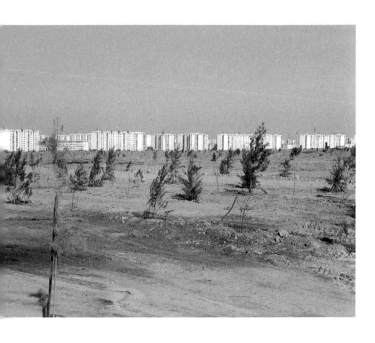

Autoportrait (detail), 1999

being committed every day. As the news of devastating violence became known, Ristelhueber wrestled with some basic issues for making art:

> How to create, how to approach societal concerns, and how to preserve the anger in me without becoming a militant? How to respect a situation while also creating a work of art? By addressing suffering that will always exist. This is how I envision art that is linked to the existing world.[26]

Ristelhueber did translate her own horror in one of her most unsettling works, *Every One* (1994). At the same time, she began to address the deception of peace within a land that was witness to brutality and bloodshed in a long-term project called *La Campagne* (1997). Each artwork was the result of consistent interests and the awareness that she could not ignore these unacceptable events.

In 1994, to show her solidarity with the city under siege, Ristelhueber returned to Sarajevo, where she exhibited *Fait* as photocopies at the Obala Art Center. She also included an image

from the recently completed *Every One*: an oversized, black-and-white photo of recently sewn flesh. When the image was exhibited in Utrecht, people widely assumed that it had been taken in Yugoslavia. In fact, Ristelhueber had found the anonymous scarred bodies that would become *Every One* in two Paris hospitals, quickly photographing the freshly cleaned stitches on the skin of patients who had just been discharged.

Despite the innocent origin of most of these scars, Ristelhueber exaggerated the undeniably difficult appearance of the images by producing them beyond human scale, approximately nine feet in height or width. She intended her subject to be unavoidable, to make the viewer think of a landscape before recognizing these scarred bodies as human forms. Every pore of the agitated surface of recently pulled skin, the result of a bandage just removed, is easily readable on this inhuman scale. The conflicting messages of mending and suffering and the scar on a patient's neck explored over a decade earlier were more fully realized in *Every One*. Rather than the emphasis on the paradox of mending

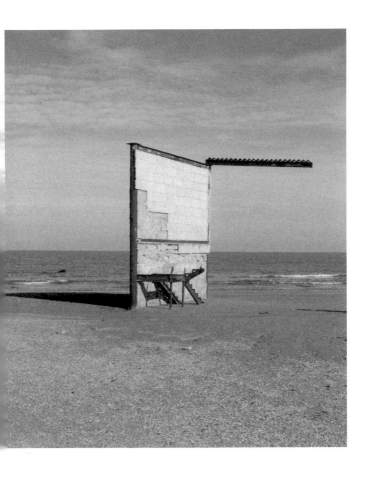

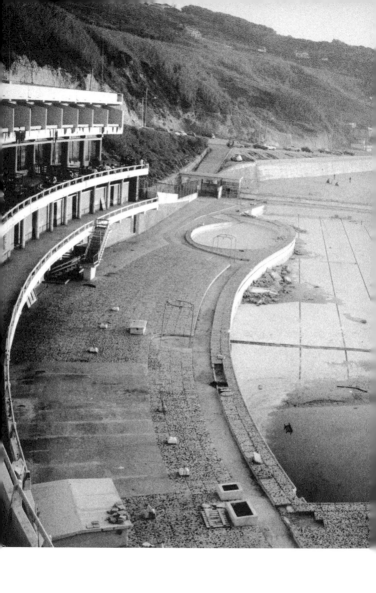

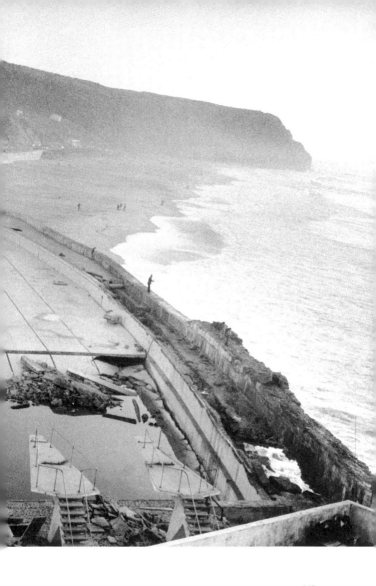

Dead Set, 2001

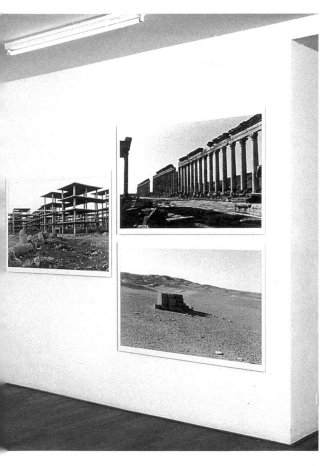

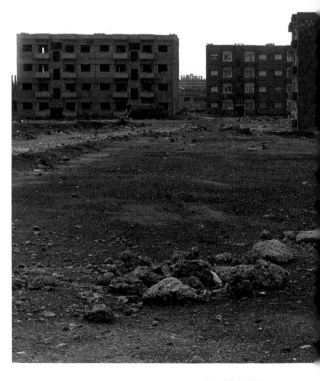

Dead Set, 2001

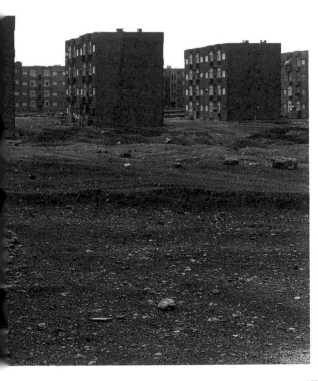

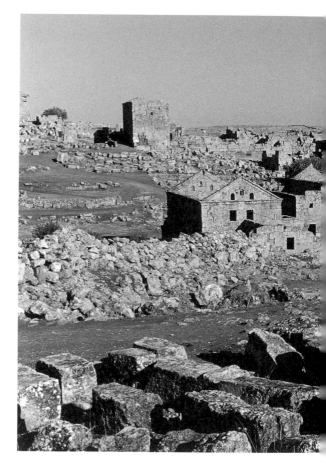

Dead Set, 2001

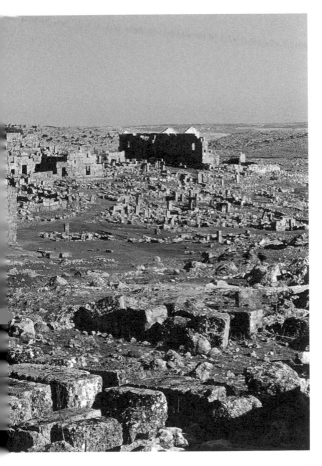

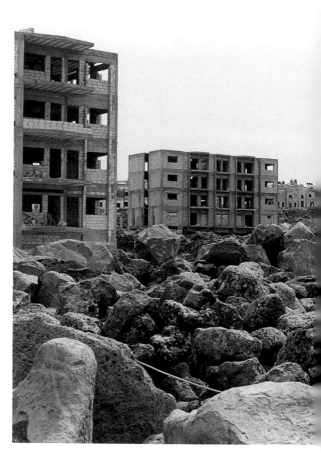

Dead Set, 2001

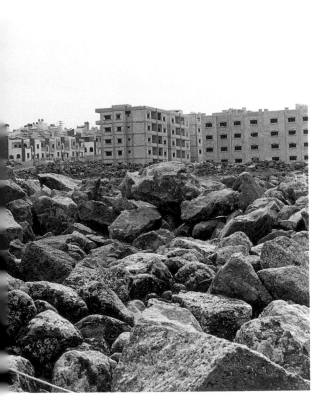

with violence, the violated flesh of *Every One* allowed her to encourage our questioning of the potential and reality of barbaric treatment by one's neighbors as the residents of the former Yugoslavia inflicted on each other. It was her alternative to the images of murders and atrocities taken throughout the decade and captured by journalists—many of whom still speak of how helpless they were, and how little power their photographs had to change anything.

For the small, thin volume that accompanied *Every One*, Ristelhueber chose simple blue paper to shield the fourteen black-and-white images of naked, vulnerable flesh. Woven between these reproductions and printed on transparent, skin-like paper, is an excerpt from the first written document to attribute war as one man inflicting violence against another, rather than avenging the gods. The *History of the Peloponnesian War* was written by Thucydides in the fifth century BC, but could speak of every conflict since then:

> In their struggle for ascendancy nothing was barred; terrible indeed were the actions to

which they committed themselves, and in taking revenge they went farther still. Here they were deterred neither by the claims of justice nor by the interests of the state; their one standard was the pleasure of their own party at that particular moment, and so, either by means of condemning their enemies on an illegal vote or by violently usurping power over them, they were always ready to satisfy the hatreds of the hour. Thus neither side had any use for conscientious motives; more interest was shown in those who could produce attractive arguments to justify some disgraceful action.

The clarity and directness of *Every One* stand in opposition to the equally disquieting installation *La Campagne*, which demands the viewer's persistence before revealing its depths. Choosing a title that means both "countryside" and "military campaign," Ristelhueber used her own encounter with the former Yugoslavia to convey the awareness of what had unfolded upon it. Most of the images were taken during the sum-

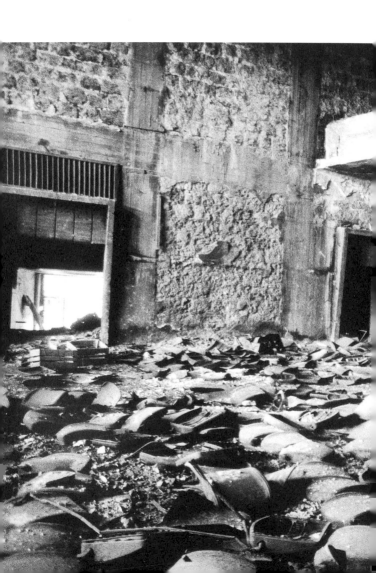

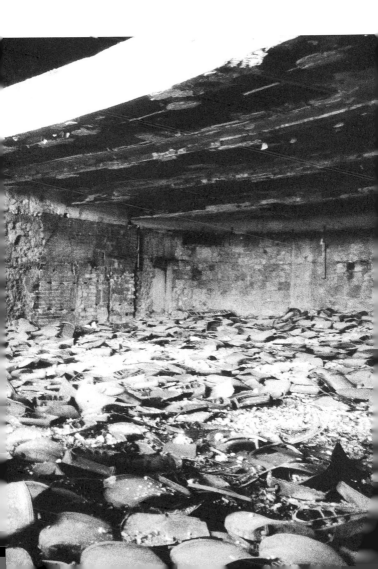

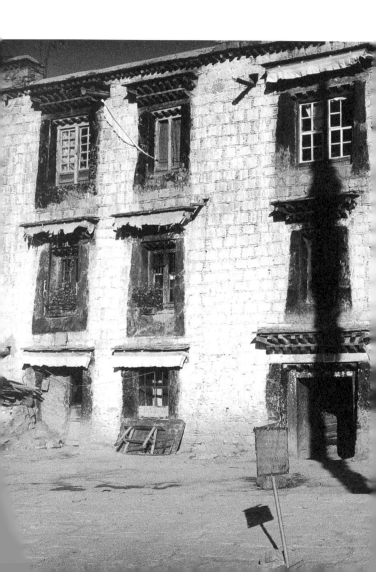

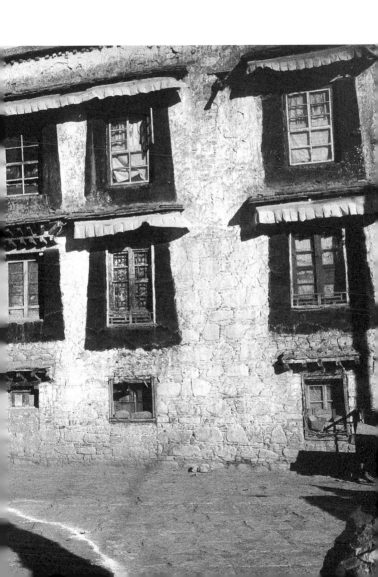

mers of 1996 and 1997 in "liberated Bosnia." A few years earlier, on assignment in the Pilat region of France, she had realized that the area looked unnervingly like Bosnia. It was unbearable to think that only a short distance away from the Pilat, a nearly identical landscape was completely ravaged. It brought home all the more forcefully the incomprehensible violence that has always been associated with establishing boundaries—as well as the knowledge that the "other," ultimately, is like you and me.

The exhibition of *La Campagne* was designed to encourage the casual perception of the works. The photographs were mounted like posters, taking away their preciousness and dismissing the sense that the traditional respect and care for an artwork applied to them. Some thirty images were rested directly on the floor, without frames, leaning against the wall, one haphazardly placed on top of another so as to cover or partly reveal what was underneath. As in Robbe-Grillet's novels, each detail, while replacing the former, offers little illumination of a complete truth. The terror of a specific moment or place is not made obvious to the viewer through the selection of

Mémoires du Lot (detail), 1990

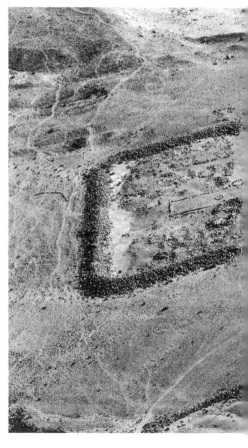

Mémoires du Lot (detail), 1990

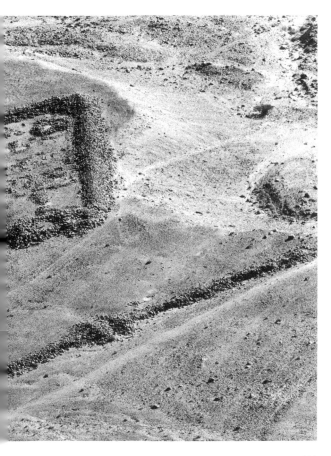

Mémoires du Lot (I) (detail), 1990

Mémoires du Lot (II) (detail), 1990

images. Instead, Ristelhueber offers only a list of the locations where the scenes were found: Mostar, Sarajevo, Srebrenica, etc. The viewer gradually discovers the disturbing details of what first appears to be a quiet landscape. Particularly when Ristelhueber describes *La Campagne*, she is able to point out that a certain hill "is where survivors of the massacre at Srebrenica tried to escape," or that "the trees aren't naturally short, but were broken by shooting," or that "this chalet was owned by the former dictator Tito, whose death preceded the most recent episode of civil war." She can tell you that this picture is "a nice landscape," but that at her back is "a whole village destroyed because of genocide: just turn your feet from the scene and you are facing horror"[27]; and that the muddy lane in the foreground is the result of excavations out of her framed view, and that the smell of death was still in the air at her last visit. Within a familiar terrain, she found a landscape of haunting desolation.

A similar dismay about growing world conflicts and the West's half-hearted way of dealing with them lay behind her 1995 installation

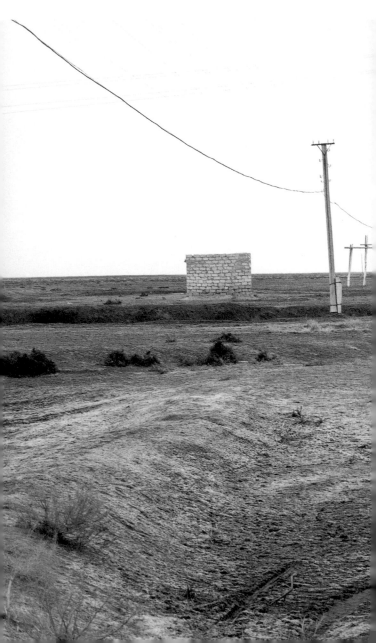

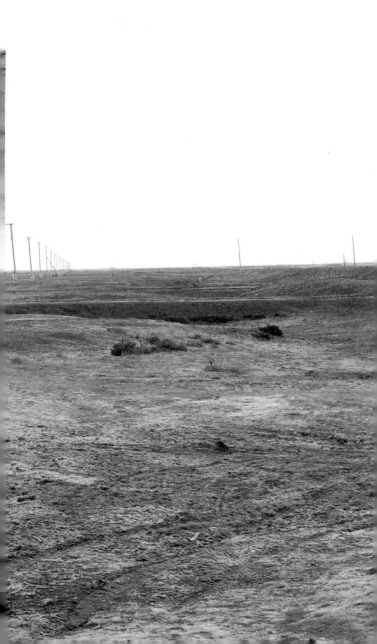

La Campagne, 1997

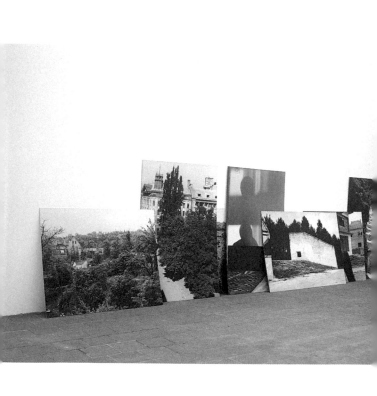

La Campagne, 1997

Resolutions. This work, however, contained no photographic elements. Commissioned on the fiftieth anniversary of the United Nations, *Resolutions* grappled with the tragic inability of even this organization, which represents the most powerful nations in the world, to respond to deepening conflicts with anything but empty phrases and inactivity. Ristelhueber—one of several major artists involved in this project—emphasized the hollowness of the UN's efforts by creating five tents, manufactured by the UN's own supplier and placed in the gardens of its Geneva headquarters, but tied shut with ropes to prevent entry. Across their canvas tops, she silkscreened snippets of generic phrases uttered in response to countless battles, endlessly repeated in the daily newspapers: "It is out of the question," "If nothing occurs," "Made threats against," "Deem unacceptable." Despite its atypical appearance in Ristelhueber's oeuvre, *Resolutions* contains all the elements of her obsessions with details, the written word, and the power of absence and contradiction.

Another project dependent on words rather than photography was the first in an ongoing

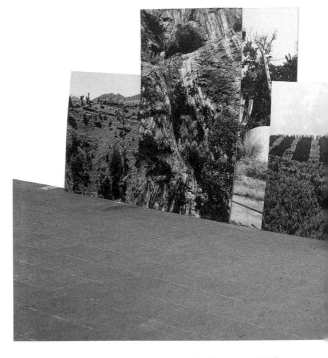

La Campagne, 1997

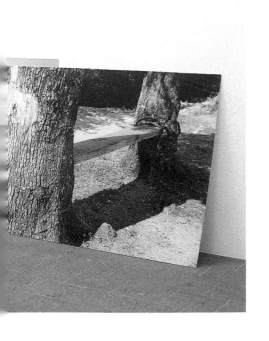

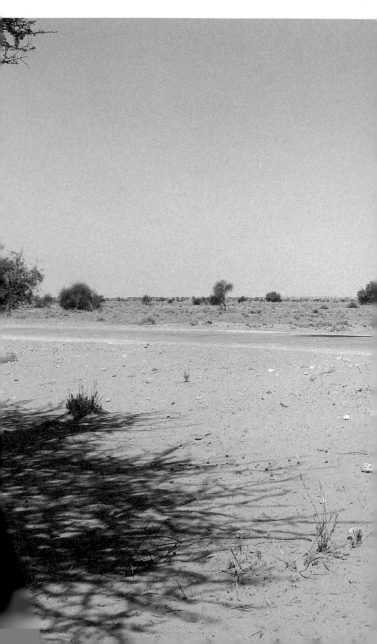

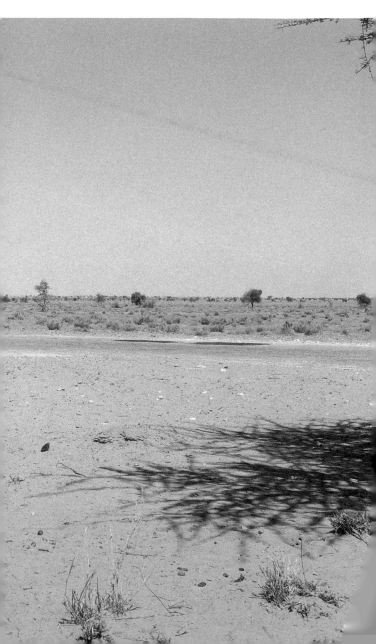

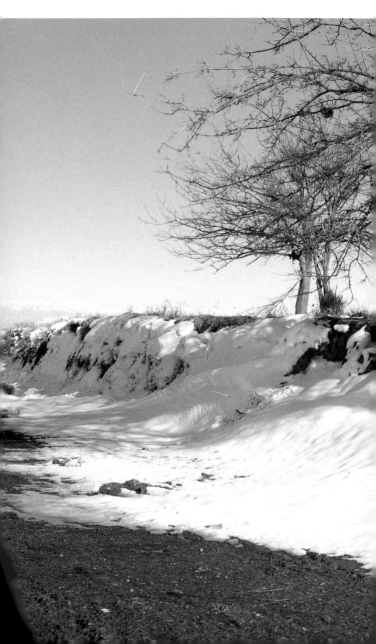

series, *L'Air est à tout le monde* (The air belongs to everyone). Titled after a game invented by Ristelhueber and her sister, Véronique, when they were children, *L'Air est à tout le monde* involved repeating this phrase and gesturing toward the head but never touching her partner; winning when the other succumbed to the threat of an attack. Ristelhueber used the form of a child's puzzle for the first version. She fabricated a metal relief grid and painted each movable square with one letter of the phrase; one square was left empty as an escape. In its second version, she enlarged the image of a landscape taken during a journey devoted to seeking out the great symbolic borders of Central Asia, in the former Soviet Union. It was positioned in the corner of a darkened room and brilliantly illuminated to give the appearance of an internal light. The blinding white dominating the center of the image originates from a flat, snow-covered surface that leads to a distant majestic mountain; only a thin, broken line disrupts the viewer's eye. It is the detail revealing the artist's stance at the border between Tadjikistan and Afghanistan. This is a photograph whose subject is the vast-

Hémisphère sud, 1998

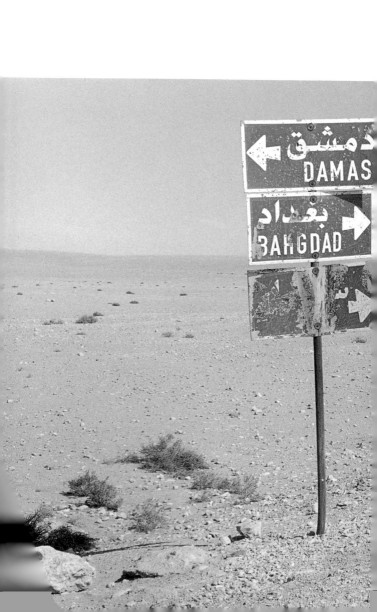

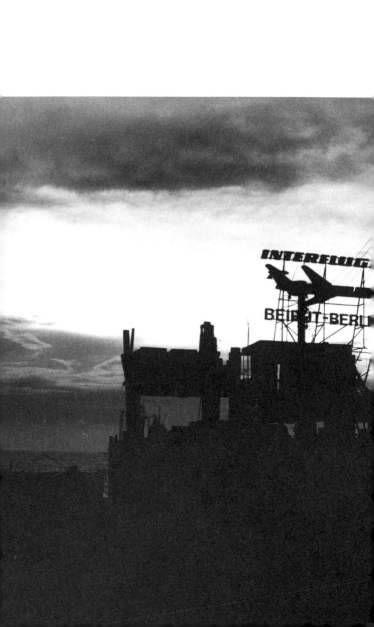

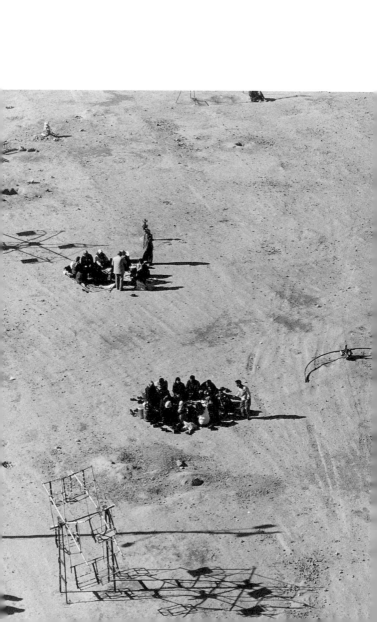

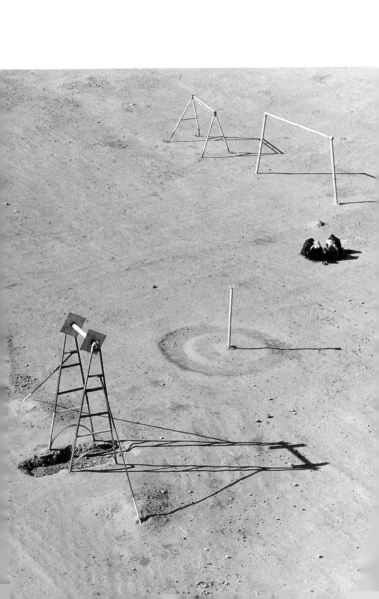

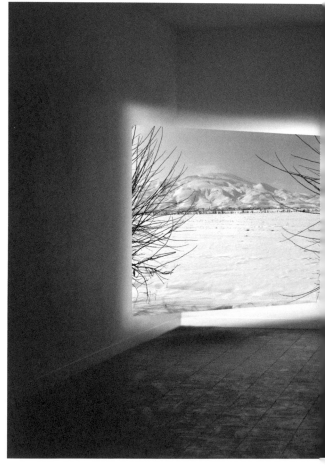

L'air est à tout le monde (II), 2000

L'air est à tout le monde (III), 2001

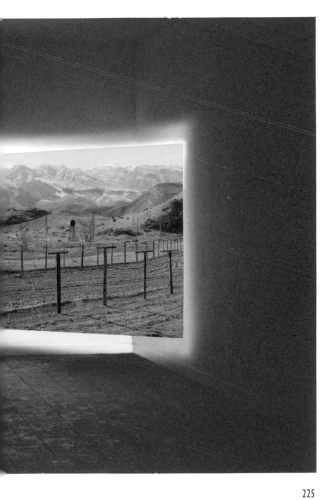

ness of a landscape, in which an incidental line distinguishing sides appears both unnecessary and offensive. The third version of the work, reproduced here for the first time, shows the border between Turkmenistan and Iran, and places even greater emphasis on the contrast between the land found on the "other" side and the territory in the foreground. It is as if the demarcations of earlier obsessions with scarred bodies, with surfaces of the battered land and the cycles they represent, are now seen for what they are: gestures in the air. Significantly, the artist recorded the ambient sound of her position as an additional component not only to mark her spot but to possess it herself.

Images from Central Asia dominate the installation *Autoportrait,* created in 1999. Conceived of in anticipation of the new millennium, this candid self-reflection also acknowledges Ristelhueber's own fifty years on this earth and questions the choices she has made as an artist. Here, ght color photographs selected from those ken in 1997 dominate the installation as free-anding, oversized objects. Hovering above

them on a wall is a reproduction of an enlarged detail of a badly damaged painting that the artist grew up with in Vulaines, an image of an older woman in a chair, discreetly attired. For Ristelhueber this image personifies a lifestyle that, in another era, would have been hers: predictable, inflexible, and following established social rituals. Positioning the painting above the arrangement of photographs as if in a place of honor or constant reminder, she suggests the stark contrast between acceptance of any history—even one describing social boundaries––and her own determination to satisfy her unceasing wanderlust. Self-deprecating in her seriousness, she added an audio component: an American auctioneer offering the passing year 1999 for sale in rapid delivery, barely comprehensible even to an English-speaking audience.

During the widespread anxiety about the coming millennium, Ristelhueber responded with an odd kind of reassurance. The images she selected are filled with the sad emptiness of places in the midst of vast territories: rarely visited, unglamorous, forgotten. They reveal evidence of a generic, unspecific modernity, once

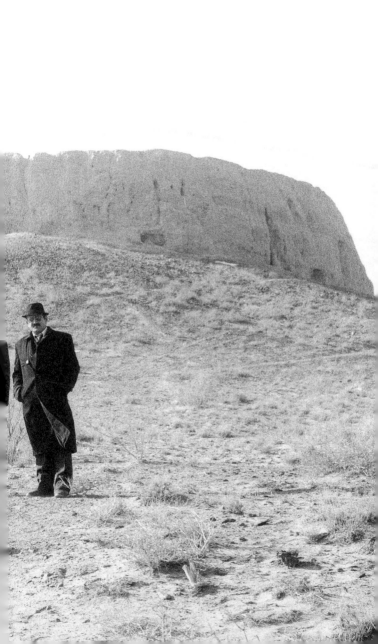

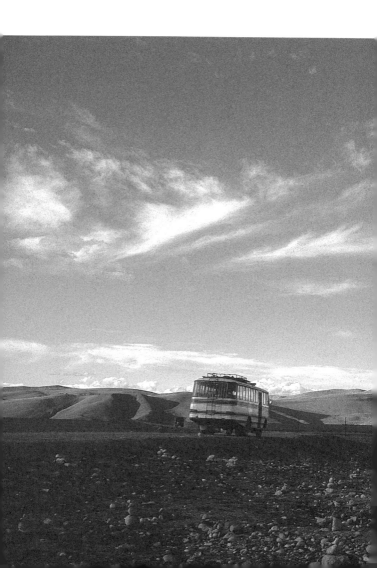

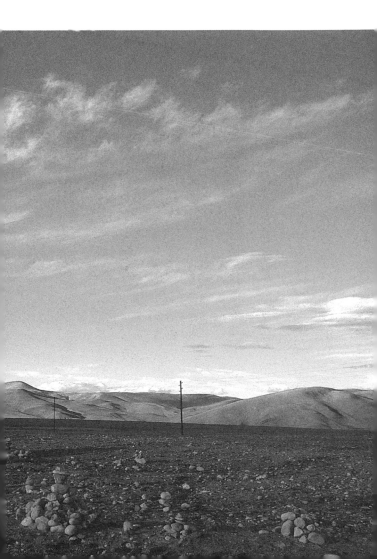

Armenia, 1989

proud and seemingly in ruins, as if asking the viewer, "Which is more awful—the concrete remnants of what once existed or the site of stark buildings whose only intent is to house a maximum number of residents?" Within these eight images are electrical wires and border crossings, a mountain seemingly at the top of the world, a cinderblock wall alone by the edge of open water, a road leading nowhere surrounded by snow-covered trees. It is as if Ristelhueber can honestly say that she has seen the worst, and it looks familiar, it's all right, we've all been through it before. There is nothing romantic about these images; she simply offers facts, details of the world. As Ristelhueber points out, Robbe-Grillet's essay "Nature, Humanism, Tragedy" could equally apply to this project:

> There are questions, and answers. Man is merely, from his own point of view, the only witness. Man looks at the world, and the world does not look back at him. Man sees things and discovers, now, that he can escape the metaphysical pact others had once concluded for him, and thereby escape servitude

Armenia, 1989

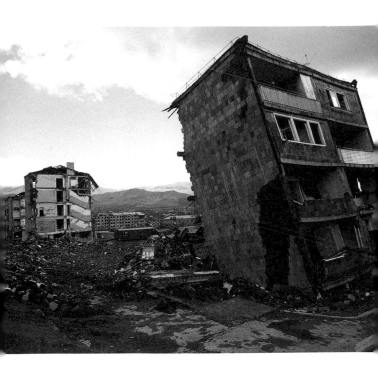

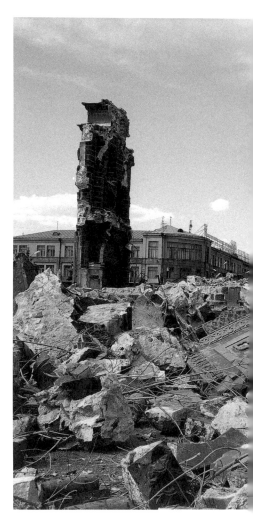

Armenia, 1989

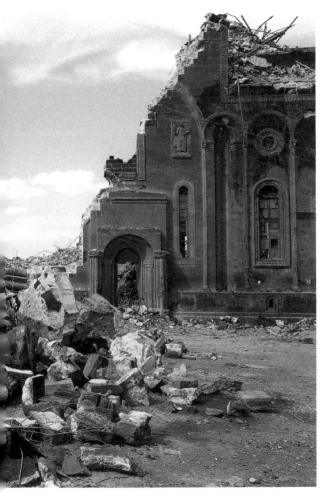

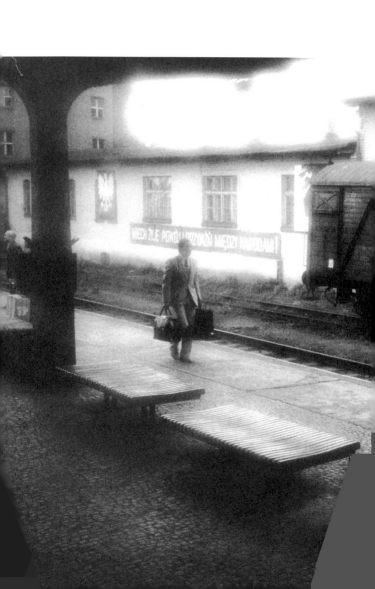

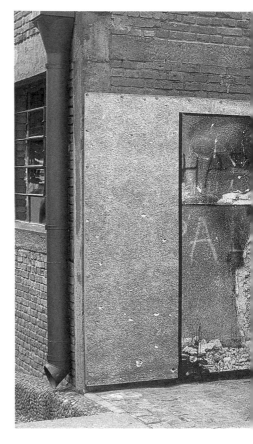

Untitled, 1998

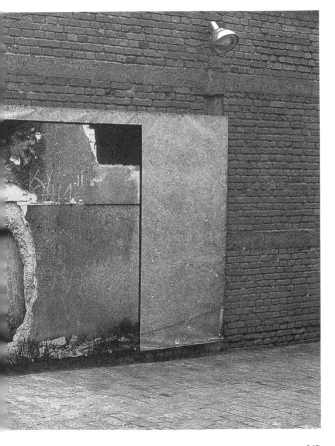

and terror. That he can…that he *may*, at least, some day.[28]

The ultimate line in the air, the equator, was in fact one of the artist's subjects in 1988. Although there were numerous locations to choose from to signify this abstract idea, Ristelhueber found latitude zero on the island of Sao Tome in the Gulf of Guinea, in a forgotten café on an overcast day. Inscribed along the base of this photograph, one of the artist's most romantic images, is the title and date. It became one of five photographs gathered together as a single work for the group exhibition *Géographiques*, organized by the Fonds Régional d'Art Contemporain in Corsica.

The other four images in *Géographiques* seem to have nothing in common with the equator photograph, and were made as far back as 1982. Formally, only one can be linked with Ristelhueber's attention to the scarred earth: it is inscribed *Chatt-al'Arab – 1991* and was taken when creating the images for *Fait*. As with the aerial views dominating this latter work, the viewer is left without clues to the scale or significance of this incised surface, cut in half by a

dark band. The photograph shows a view of Iraq and the marsh filled by the waters that lead to the Persian Gulf: this land, between the Tigris and Euphrates rivers, is the territory once known as Mesopotamia, one of the origins of civilization. *Sabra et Chatila – 1982* depicts a location so primitive that it could just as easily have been taken a century before. This was the site of a massacre of Palestinians that same year. With *Sodome – 1983*, a forlorn structure found near the Dead Sea perhaps suggests vengeance against the misdeeds of this biblical city. And *Waterloo – 1996* is a formally pure composition that seems to translate this illustrious battlefield, the site of Emperor Napoleon's last defeat, into a landscape filled with mourning. Together these more traditionally composed images of landscapes reveal a consistent interest in the paradox between the mythical associations we have with certain locations and their current state. The emphasis on physical traces upon the world is not evident, but has instead been interpreted more abstractly and conceptually. This series is also Ristelhueber's only work to date to include her handwritten inscription across the base of

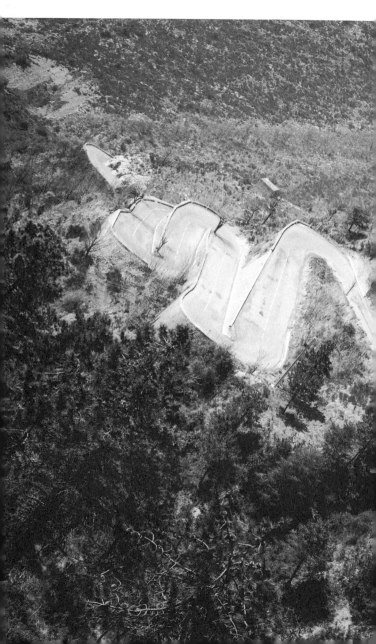

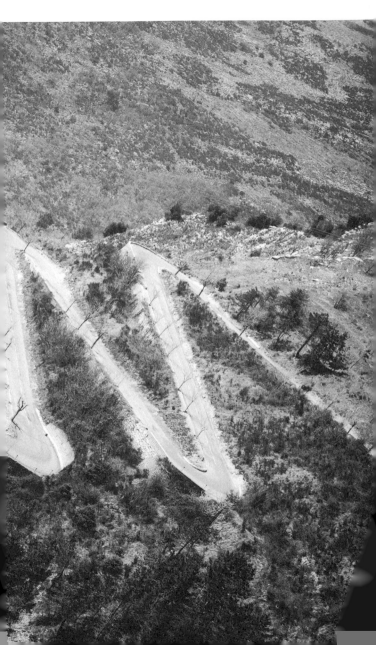

the image. It is as if she needed her own mark to suggest possession of something invisible and unobtainable, which in fact represents something very real to her.

In the spring of 2000, the Hôtel des Arts in Toulon invited Ristelhueber to create a work about the Var, the region in the south of France where this contemporary art venue is located. The result was *La Liste*, an installation of twenty-six color images accompanied by a recording and an artist's book that also served as catalogue. Mainly associated with tourism, the Var includes the glamorous Côte d'Azur and the celebrated lavender fields of Provence. The area is also widely known to be politically conservative, even corrupt: news stories have long suggested that local officials had unethical allegiances and dubious motives, put in the service of a chauvinistic nationalism. Ristelhueber concentrated on the dangerous confusion between nationalistic pride on the one hand, and intolerance for those who are different on the other. In *La Liste*, she did not represent destruction through visual details, but instead considered the deconstruction of identity

as embodied in a "list," a roster of names, most typically associated with electoral lists. Her focus was a simple organizational device with enormous significance, the assembly of names and the power each represents as a voter. To Ristelhueber, the result of generations convinced of their authority and unrelenting views has made of the Var a "lost paradise."

Using a list of over two thousand names taken from the longer official compilation identifying every mountain, river, town, and port of the Var, Ristelhueber suggests "that one can never say what a place is. [But] you can always name it."[29] It is an idea that recurs often in her work, from the pulverized buildings in Beirut to the vertiginous images of Kuwait to the silence of liberated Bosnia. To emphasize and wittily criticize the emotional fervor of flag waving, she invited the well-known French actor Michel Piccoli to recite this list and then broadcasted it outside the Hôtel, as if hearing it reaffirmed the identity of the area.

The images of *La Liste* also speak of the paradox of recognition and local tragedy. Unlike the hidden, fossilized France she perceived in this

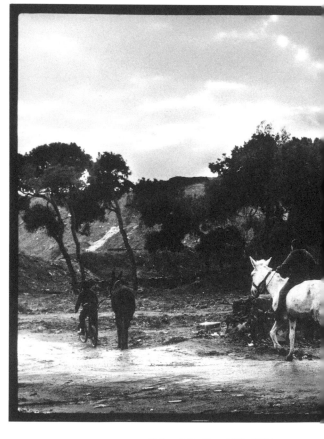

Sabra et Chatila – 1982, 1996

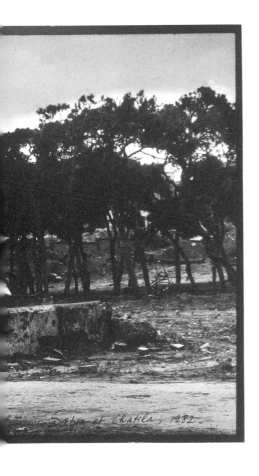

Sabra et Chatila, 1982

La Ligne de l'Equateur – 1988, 1996

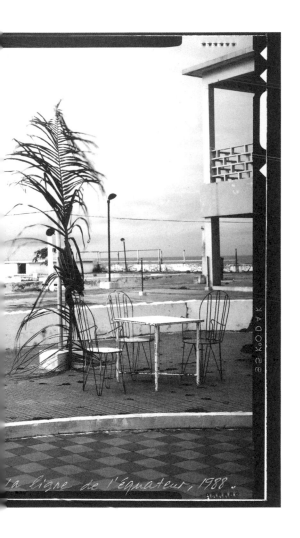

La ligne de l'équateur, 1988.

Sodome – 1983, 1996

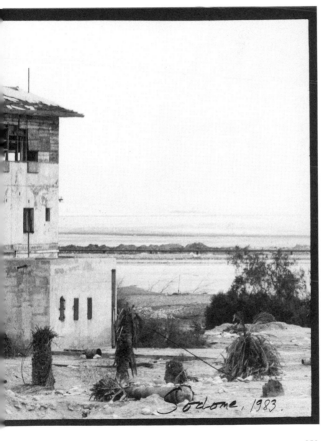

Sodome, 1983.

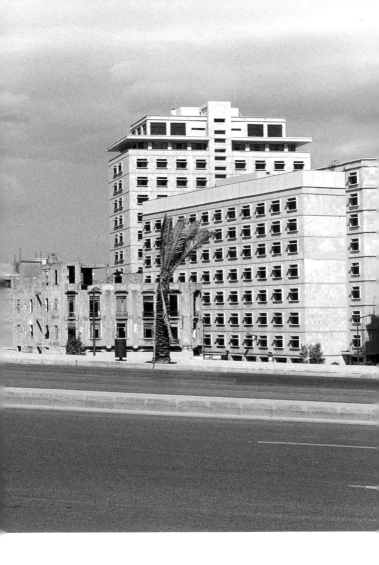

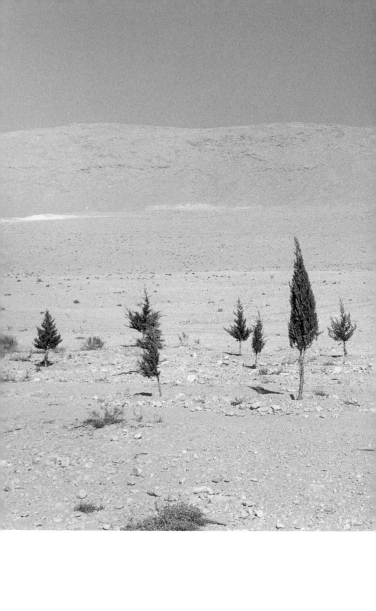

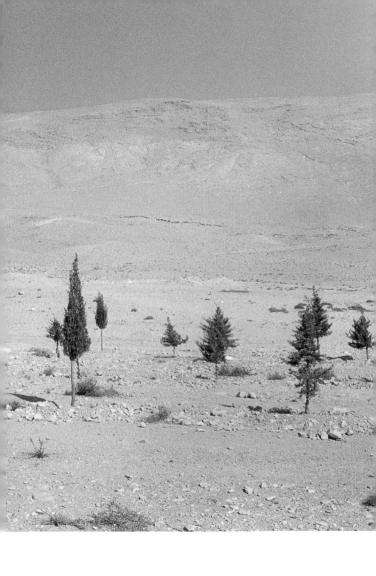

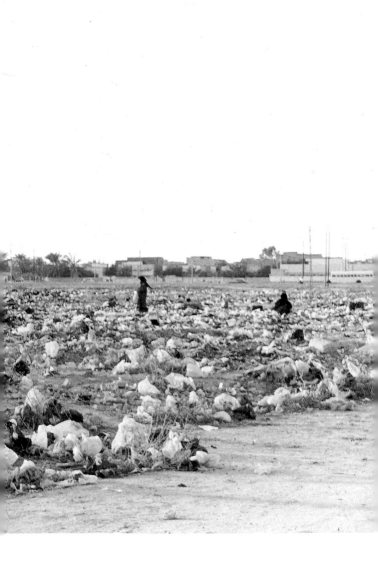

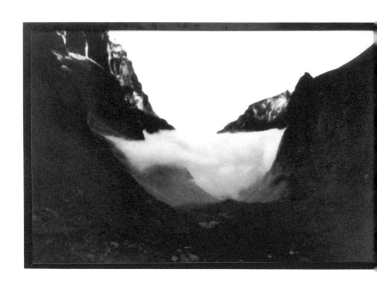

Double Bind (I), 1990

same region when commissioned by the DATAR in 1986, Ristelhueber now considered the abundance and aggression of the architecture that has "cannibalized" this tourist haunt. Her photographs, however, are not the easy images of a cynical critique of nature overrun by commercialism and bad taste. Rather, she was fascinated by the difficulty of finding evidence of the centuries that preceded the present incarnation of this area. Although the images contain their share of new residences, glistening swimming pools, seashores bordered by roads and parking lots, and mountains and fields dotted by antennas, they are primarily views of nature, in which man-made details rarely dominate. Instead, the only consistency is the palette created by the "natural" landscape of blue, green, white, and brown bathed in sunlight. History and nature are highly controlled here.

Taking the temporary nature of the *La Campagne* reproductions even further, Ristelhueber made digital versions of her photographs for *La Liste* on paper. She carefully arranged them within the elegantly proportioned rooms of the villa that houses the art center, then glued them

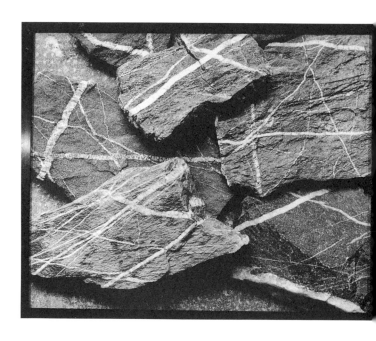

French Pass, 1990

directly to the walls. By selecting this form of reproduction, Ristelhueber was not only able to fill the spacious "galleries" of this grand residence, but seemed to possess the space by incorporating architectural elements as mere borders to her images. The accompanying publication reproduced the same photographs on pages of different sizes, overlapping each other much in the same way as viewers experienced *La Campagne*.

Just prior to creating *La Liste*, Ristelhueber finally succeeded in fulfilling her desire of nine years to enter Iraq. The thrill of succeeding was to be matched by the panic she experienced once there: self-imposed pressure to take advantage of this one-time opportunity was foremost in her mind, yet she felt compelled to take only a small number of pictures. It wasn't the circumstances under which she was forced to work that discouraged her photography, nor was the situation more alarming than previous experiences. Rather, the visit to Iraq, a personal journey to a part of the world previously seen in the aftermath of battle, seemed to suggest that her

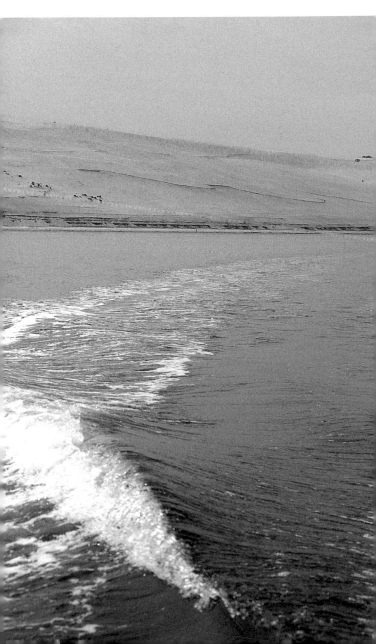

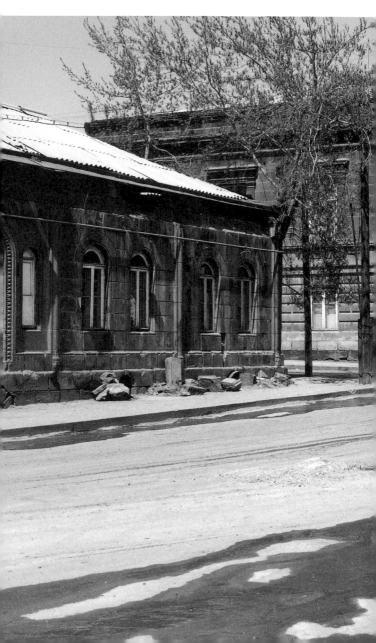

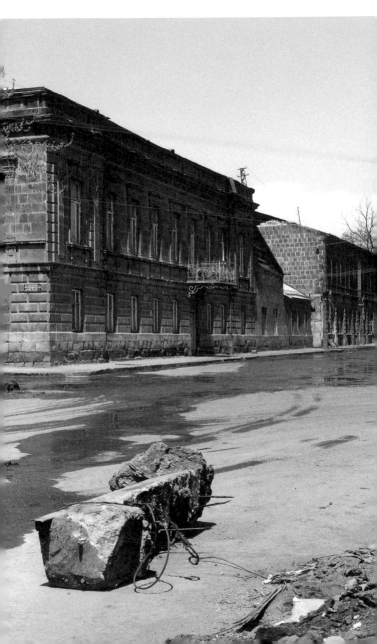

Les Trois Sœurs, 1996

obsessions may no longer be appeased through the medium of photography, that visiting this area of the world at this time was itself a climactic fulfillment. But once she was in Iraq, her next step perplexed her:

> I *had* to go there, and finally I could, but once there I didn't know what to do. Of course there were many pictures I could have taken of the horrible conditions, but I did not. I could not. What I found was a devastated country, and just as I was so attracted and sickened by the abandoned objects of the Iraqis in Kuwait and the homes torn apart in Bosnia, I felt the same way. The only thing that really struck me was the yellow sand and those thousands of dead palm trees, black and burnt like an army of dead soldiers. And that will be my piece.[30]

Continually questioning her world, Ristelhueber confronts it while the means of expressing what she has learned increasingly perplex her. Her ongoing project on borders and frontiers—means of division that have been the source for

conflict and inspiration throughout our existence—has recently taken the form of works such as *L'air est à tout le monde (III)* and *Dead Set* (both 2001), but in starkly contrasting images. Her visit to Iraq in 2000 may signal that her longstanding obsession with traces and ruptures will now be explored in a much more abstract way. Ristelhueber's attention to objective reality has in part moved away from visible evidence, toward that which can only be understood rather than seen. Reflecting on her trip to Iraq, she found that her deep connection with this place still reveals an obsession with the unceasing activity of construction and destruction, yet the surface wounds no longer suffice as the greatest description. Her relationship with her subjects—whether the pulverized buildings of Beirut or ancient Mesopotamia—remains the same, while the visual realization of her interest has evolved.

Ristelhueber has rarely been so overwhelmed by an environment or situation that she has found it impossible to create an artwork based on the experience. *French Pass* (1990), an image of several overlapping dark rocks with

contrasting white veins running through them, was one of only two works to result from an emotionally moving experience (trekking the Himalayas in the winter of 1988), which showed her that experience and direct depiction are often not compatible. This single image, made in the artist's studio from rocks she carried back with her, reveals elements that would imbue all of her later work.

In the case of Iraq, the humbling experience came, if anything, from the wreckage surrounding her, rather than the physical grandeur. The trip to Iraq was a solitary and personal journey near an area (Kuwait) that she had previously experienced when it was still reeling from battle and overrun by foreign correspondents. This time, the welcome solitude must have encouraged reflection on what she has achieved as an artist, even as it threw doubt on where she could next be heading. Entering Iraq also symbolized the extraordinary accomplishment of a seemingly impossible objective. Determined to reach the Persian Gulf from within the boundaries of a forbidden land, she also knew that she would enter the heart of one of the first centers of human civ-

ilization, Mesopotamia, where we credit the origin of the first city and the invention of writing. It is an area that symbolizes all her preoccupations and that has provided ideas and imagery for much of her work. As she attempted to put her own two feet on the land near the mouth of the Persian Gulf, she faced the current reality of Mesopotamia, finding unnatural colored sand and little if any vegetation left alive. Was it now difficult to conceptualize this as evidence of the unceasing cycles of construction, when this barren land made destruction so profound? Was this the worst that can happen? Were physical divisions of territories and human traces inconsequential in this version of reality, which appeared to leave no evidence of any history? Is this the "time of destruction" predicted by Lucretius, in which we are so loath to believe? Is this, simply, what *is*?

Perhaps this recent journey to Iraq was Ristelhueber's destiny. It reveals the consistency of her obsessions and conceptual interests: an abiding concern with geopolitics as manifested in physical evidence, which she restructures with images and words and expresses in a thoughtful, time-

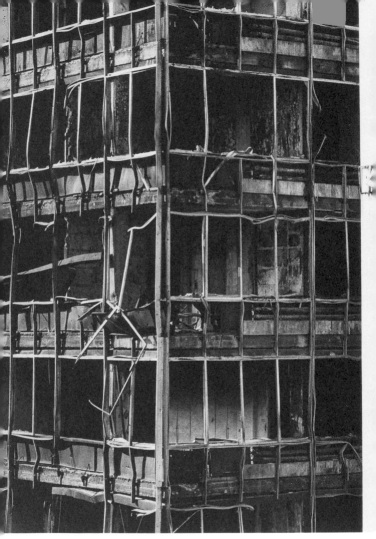

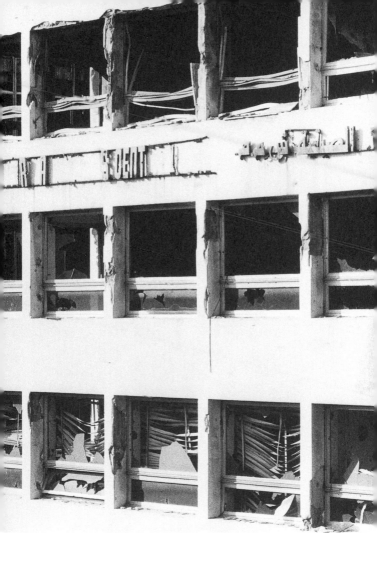

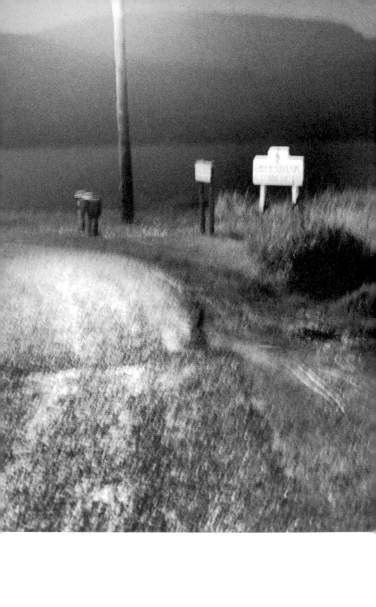

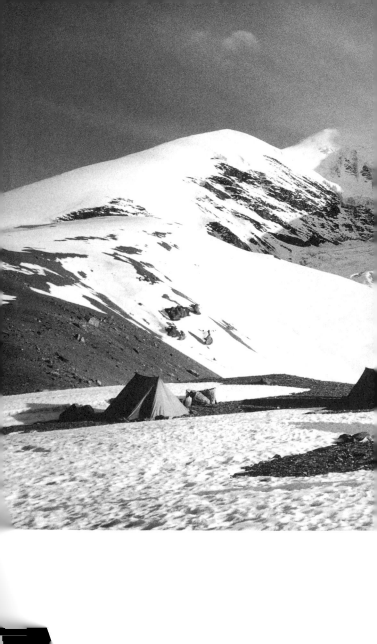

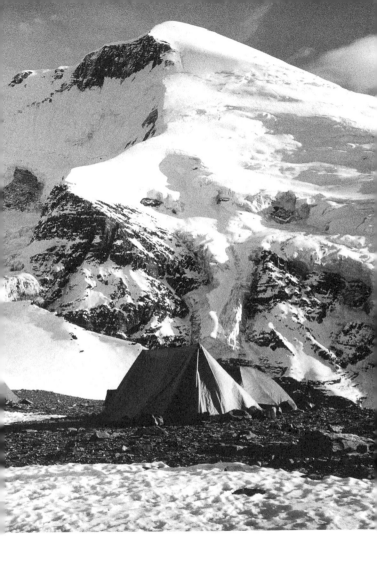

less voice. Perhaps this location is indeed a culmination, as suggested in a work of a decade before, *Mémoires du Lot* (1990), in which the "original" traces left by prehistoric civilizations encouraged her to consider the condition that precedes any history. She fabricated her own prehistory as an allegorical response to a commission by the Lot, a region in the southwest of France, not far from the Lascaux caves where evidence of fossils and tracks revealed man before civilization. The project was made for presentation in a small chapel and included a triptych of black-and-white photographs, as well as two comparatively minuscule images placed on the end of each pew (although none featured the river Lot of the title). These smaller images were contrasting views of a plaza filled with people, reduced at this scale to mere patterning, and a desert landscape with striations uncannily forming a cross. These traces, found while looking over the site of the ancient city Masada in the Israeli desert of Negev, preceded *Fait* by nearly a decade. Ristelhueber further acknowledged the identity of this exhibition space by creating a "prayer book" that opened

with her own words:

> I met, on the banks of the Lot, the rhinoceros,
> the mammoth, and Homo sapiens.
> The world was not a landscape.

The three black-and-white photos visualized these words through allegorical images, while an additional text for *Mémoires du Lot*, the Prologue to the Book of Ecclesiastes, suggests not only the subject underlying Ristelhueber's work, but also a sobering realization that she has keenly understood and realized throughout her artistic odyssey:

> A generation goes, and a generation comes, but the earth remains for ever. The sun rises and the sun goes down, and hastens to the place where it rises. The wind blows to the south, and goes round to the north; round and round goes the wind, and on its circuits the wind returns. All streams run to the sea, but the sea is not full; to the place where the streams flow, there they flow again. All things are full of weariness; a man cannot utter it; the

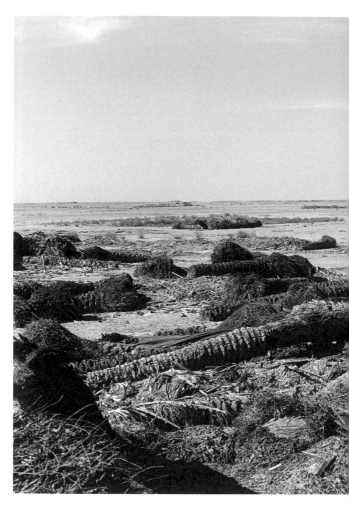

Iraq, 2001

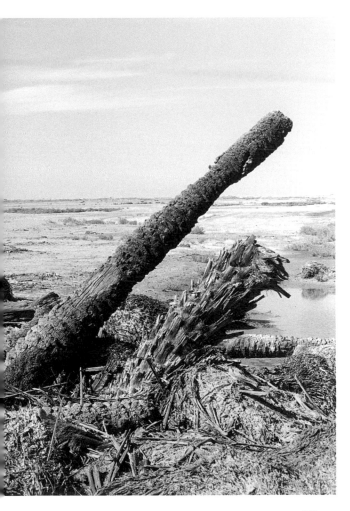

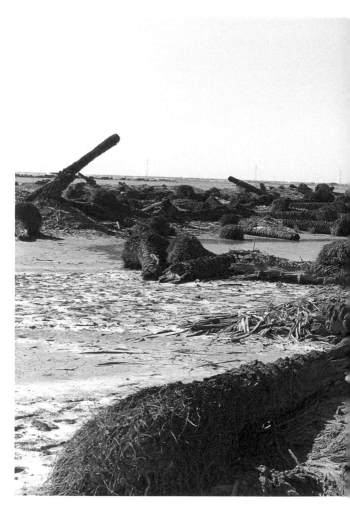

Iraq, 2001

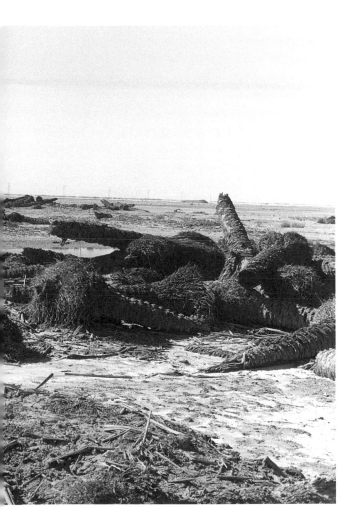

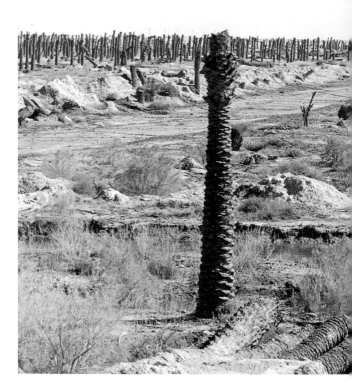

Iraq, 2001

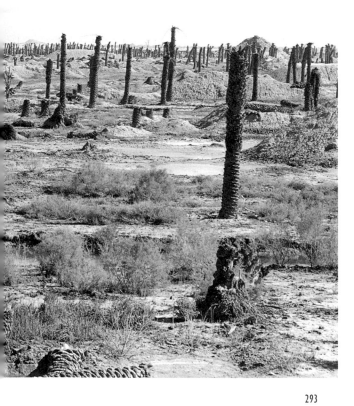

eye is not satisfied with seeing, nor the ear filled with hearing. What has been is what will be, and what has been done is what will be done; and there is nothing new under the sun. Is there a thing of which it is said, "See, this is new"? It has been already, in the ages before us. There is no remembrance of former things, nor will there be any remembrance of later things yet to happen.

Never disillusioned by her journeys, Ristelhueber understands that the cyclical nature of life evident within her projects is even found in her own artistic approach. Her obsessions have not been easy to quell, and the effort to do so speaks of something within the creative process that is so deeply felt, that it is difficult for even the artist to believe the extraordinary efforts she has taken to realize an idea. But these efforts are her means to face reality and allow her to speak of eternal ideas and insoluble dilemmas.

Although Ristelhueber's intense gaze and use of photography places her within a vast artistic community, her allegiance to text and the con-

ceptualization of ideas based on a direct experience sets her work apart from most. The intensity of statements such as *Beirut, Fait,* and *Every One*—as art that considers the subject of war without the suggestion of judgement or sentimentality—also allows for few comparisons. Through an emphasis on absence as a substitute for the fragile presence of life, Ristelhueber suggests with quiet optimism and wisdom that this is only the expected and inevitable progression of history. She offers nothing more than simply what is, and passionately avoids manipulating the viewer's response. Instead, it is the viewer who must create his own reality—or fiction—from her suggestions, each version displacing the previous. A passage by Robbe-Grillet in his 1961 essay "New Novel, New Man," singled out by Ristelhueber, sheds light on her approach:

> The modern novel, as we said at the start, is an exploration, but an exploration which itself creates its own significations, as it proceeds. Does reality have a meaning? The contemporary artist cannot answer this question: he knows nothing about it. All he can

say is that this reality will perhaps have a meaning after he has existed, that is, once the work is brought to its conclusions."[31]

While Ristelhueber's unaltered still images bear no resemblance to those of a journalist, they do indeed figure as confirmation of what has been seen; in fact, it is for this role above all others that Ristelhueber has found photography suitable to her purposes. Yet she recognizes that her attention to a location is an attempt to face what she has found to be a version of reality without illusion, sensation, or exaggerated self-reflection. Her depiction of our surroundings and the marks left behind, whether on the scale of an incision into flesh, pulverized concrete, or trenches in the desert, is a gesture filled with endurance and repetition. And even when these traces do not appear in her images, do not believe that they are no longer to be found. Consider the photographs of Sodom or Srebrenica, seemingly simple, but with names that suggest events from centuries earlier or the power of an abstract boundary in a vast, empty territory. These, too, are the details of the world that Ristelhueber can-

not dismiss. Whether visible or invisible, these lines obviously or subtly acknowledge the state of our existence; they are offered without the artist's cynicism, sentimentality or mourning. Ristelhueber's work is not illustrative or overtly emotional, but rather is evidence of insightful knowledge and a sensitive eye that has evolved from sharp observation and contemplation of the written word. Sophie Ristelhueber's photographs and installations are born of the present with insight into the past. They offer an opportunity to reflect on the moment, but suggest that you not become too lost in it because nothing is what it appears to be. The dust is still settling.

Notes

1. Sophie Ristelhueber, lecture presented at the Albright-Knox Art Gallery, April 4, 1998.

2. Michel Guerrin, "Les Obsessions de Sophie Ristelhueber," *Le Monde* (Paris), September 28, 1992, p. 14.

3. Ibid.

4. Ibid.

5. Alain Robbe-Grillet, "A Future for the Novel," in *For a New Novel: Essays on Fiction*, trans. Richard Howard (Evanston, Illinois: Northwestern University Press, 1965), p. 19.

6. Roland Barthes, "Objective Literature: Alain Robbe-Grillet," in *Two Novels by Robbe-Grillet*, trans. Richard Howard (New York: Grove Press, 1965), p. 25.

7. Sophie Biass-Fabiani and Sophie Ristelhueber, "Entretien," in *La Liste: Sophie Ristelhueber* (Toulon: Hôtel des Arts, Centre méditerranéen d'art, 2000), p. 4.

8. Ristelhueber to the author, January 26, 2001.

9. Ann Hindry, *Sophie Ristelhueber,* trans. Simon Pleasance and Fronza Woods (Paris: Editions Hazan, 1998), p. 51.

10. Ristelhueber to the author, January 26, 2001.

11. Ibid. In part, Ristelhueber is quoting her own earlier remark: see Hindry, *Sophie Ristelhueber*, p. 76.

12. Guerrin, "Les Obsessions," p. 14.

13. Ristelhueber, interview with the author, Paris, October 2000.

14. Hindry, *Sophie Ristelhueber*, p. 86.

15. *Paysages Photographies: En France les années quatre-vingt* (Paris: Editions Hazan, 1989), p. 122.

16. Guerrin, "Les Obsessions," p. 14.

17. Michel Guerrin, "Les 30/40 ans: une génération culturelle," *Le Monde* (Paris), June 1993, p. 19.

18. Robbe-Grillet, "A Future for the Novel," p. 19.

19. Alain Robbe-Grillet, *Jealousy*, in *Two Novels*, p. 48.

20. Ian Walker, "Desert Stories or Faith in Facts?" in *The Photographic Image in Digital Culture*, ed. Martin Lister (London and New York: Routledge, 1995), p. 237.

21. Guerrin, "Les 30/40 ans," p. 19.

22. Hindry, *Sophie Ristelhueber*, p. 76.

23 Guerrin, "Les Obsessions," p. 14.

24. Ibid.

25. Guerrin, "Les 30/40 ans," p. 19.

26. Ibid.

27. Ristelhueber, lecture at Albright-Knox, April 4, 1998.

28. Alain Robbe-Grillet, "Nature, Humanism, Tragedy," in *For a New Novel*, p. 58.

29. Biass-Fabiani and Ristelhueber, "Entretien," p. 4.

30. Ristelhueber, interview with the author, Boston, December 2000.

31. Alain Robbe-Grillet, "New Novel, New Man," in *For a New Novel*, p. 141.

List of Works

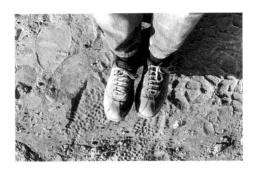

Dimensions are given in centimeters and inches, height preceding width. *indicates both vertical and horizontal formats

6-7
Germany, 1987

8-9
Rome, 1982

10 through 19
Beirut, Photographs, 1984
Selection from 31 silver prints
19 x 28.5 cm (7½ x 11¼ in.)*
each, unique

20-21
Tashkent, 1997

22-23
Caspian Sea, 1997

24-25
Tadjikistan, 1997

26-27
Every One (#1), 1994
Black-and-white photograph
mounted on fiberboard
270 x 180 cm (106¼ x 70⅞ in.),
unique
Installation at Koldo Mitxelena
Kulturunea, San Sebastián,
Spain, 2000

28
Every One (#5), 1994
Black-and-white photograph
mounted on fiberboard
180 x 270 cm (70⅞ x 106¼ in.),
unique
Installation at Galerie Arlogos,
Nantes, France, 1994

30-31
Every One (#14), 1994
Black-and-white photograph
mounted on fiberboard
270 x 180 cm (106¼ x 70⅞ in.),
unique
Installation at Galerie Arlogos,
Nantes, France, 1994

33
Every One (#3), 1994

Black-and-white photograph
mounted on fiberboard
270 x 180 cm (106¼ x 70⅞ in.),
unique
Installation at Galerie Arlogos,
Nantes, France, 1994

35
Every One (#8), 1994
Black-and-white photograph
mounted on fiberboard
270 x 180 cm (106¼ x 70⅞ in.),
unique
Installation at Le Consortium,
Dijon, France, 1995

36-37
France, 1990

38 through 41
Beirut, 1982

42-43
Jerusalem, 1983

45
L'air est à tout le monde (I),
1997
Paint on 19 metal frames
77 x 54 cm (30⅜ x 21¼ in.)

48-49
Belgium, 1980

50-51
France, 1984

52-53
Beirut, 1982

54 through 59
La Liste, 2000
Selection from 26 **color(?)** digital
prints glued to the walls
134 x 167 cm (52¾ x 65¾ in.)*
each, edition 5
Installation at Hôtel des Arts de
Toulon, France, 2000
(pp. 56-57 shows the triptych
The Flag)

60-61
France, 1986

62-63
Armenia, 1989

64-65
French Riviera, 1986

66 through 68
Resolutions (detail), 1995
5 canvas tents with silk-
screened lettering
200 x 350 x 250 cm (78¾ x
137⁷⁄₁₆ x 98⁷⁄₁₆ in.) each
Installation at United Nations
Headquarters, Geneva,
Switzerland, during
the exhibition
Dialogues of Peace, 1995

72-73
Baku, 1997

74-75
France, 1984

76-77
Sarajevo, 1996

79
Vulaines V, 1989
Diptych: color and black-and-
white photographs mounted
on aluminum and framed
200 x 245 cm (78¾ x 96⁷⁄₁₆ in.)
overall, unique
Installation at Joost Declercq
Gallery, Ghent, Belgium, 1989

80-81
Vulaines III, 1989
Diptych: black-and-white and
color photographs mounted
on aluminum and framed
162 x 280 cm (63¾ x 110¼ in.)
overall, unique
Installation at Joost Declercq
Gallery, Ghent, Belgium, 1989

84-85
Vulaines I, 1989
Diptych: black-and-white and
color photographs mounted
on aluminum and framed
162 x 410 cm (63¾ x 161⅞ in.)
overall, unique
Installation at Joost Declercq
Gallery, Ghent, Belgium, 1989

86-87
Pakistan, 1999

88-89
Leninakan, 1989

90-91
Bosnia-and-Herzegovina, 1996

92 through 98
*La Mission photographique de
la DATAR*, 1984
Silver prints, edition 3
50 x 60 cm (19¹¹⁄₁₆ x 23⅝ in.)*

100-101
Antwerp, 1992

102-103
Paris, 1984

104-105
Ahmadi, Kuwait–Iraq border,
1991

106-107
Fait, 1992
71 color and black-and-white
photographs mounted
on aluminum and framed
100 x 130 x 5 cm (39⅜ x 51³⁄₁₆ x
2 in.) each, edition 3
Installation at the Albright-Knox
Art Gallery, Buffalo, New York,
1998

109 through 116
Fait (details), 1992

118-119
Samarkand, 1997

120-121
Duchambé, 1997

122-123
Uzbekistan, 1997

124 through 128
Intérieurs, 1981
Selection from 31 silver prints
50 x 40 cm (19¹¹⁄₁₆ x 15¾ in.),
edition 3

130-131
Meudon, 1983

132-133
Baghdad highway, 2000

134-135
Japan, 1998

138-139
Les Ours d'Hartung, 2000
Diptych: black-and-white digital
prints mounted on aluminum
60 x 74 cm (23⅝ x 29⅛ in.)
each, edition 5

140-141
France, 1990

142-143
Beirut, 1982

144-145
Babylon, 2000

146 through 150
Les Barricades mystérieuses,
1995
Color photograph mounted on
aluminum
69 x 85 cm (27³⁄₁₆ x 33⁷⁄₁₆ in.),
edition 3

152-153
Kosovo, 1991

154-155
Serbia, 1991

156-157
Paris studio, 1990

158-159
Autoportrait, 1999
1 color digital print on drop
paper
410 x 200 cm (161⁷⁄₁₆ x 78¼ in.),
unique
8 color digital prints mounted
on aluminum
156 x 193 cm (61⁷⁄₁₆ x 76 in.)*
each, unique
Installation at Galerie Arlogos,
Paris, 1999

161 through 165
Autoportrait (details), 1999

166-167
Portugal, 1981

168-169
Alsace, 1983

170-171
Parc de Sceaux, 1982

172-173
Dead Set, 2001
Color digital prints mounted
on aluminum
90 x 126 cm (35½ x 49⅝ in.)
each, edition 3
Installation at Galerie Blancpain-
Stepczynski, Geneva, 2001

174 through 179
Dead Set (details), 2001

182-183
Beirut, 1981

184-185
Villefranche-sur-Mer, 1986

186-187
Lhassa, 1987

189
Mémoires du Lot (detail), 1990
Silver prints
9 x 13.5 cm (3⁹⁄₁₆ x 5⁵⁄₁₆ in.) each

Artist's book
11 x 8.5 cm (4⁵⁄₁₆ x 3⅜ in.)
Installation at Chapelle des
Arques, Lot, France, 1990

190-191
Mémoires du Lot (detail), 1990
Silver print
9 x 13.5 cm (3¾₆ x 5⁵⁄₁₆ in.),
edition 3

192-193
Mémoires du Lot (I) (detail),
1990
Silver print
127 x 186 cm (50 x 73¼ in.),
edition 3

194
Mémoires du Lot (II) (detail),
1990
Triptych: silver prints
81 x 118 cm (31⅞ x 46⁷⁄₁₆ in.),
159 x 126 cm (62⅝ x 49⅝ in.),
81 x 118 cm (31⅞ x 46⁷⁄₁₆ in.),
unique
Installation at the Chapelle des
Arques, Lot, France, 1990

196-197
French Riviera, 1986

198-199
Aral Sea, 1997

200-201
Armenia, 1989

202-203
La Campagne, 1997
22 digital color and black-and-
white prints mounted
on cardboard
Dimensions variable,
approximately 22.8 m (75 ft.)
overall, unique
Installation at Galerie Arlogos,
Nantes, France, 1997

258-259
Sodome – 1983, 1996
Black-and-white photograph
mounted on fiberboard
109 x 155 cm (42¹⁵⁄₁₆ x 61 in.),
edition 3

260-261
Beirut, 1999

262-263
Dead Set (detail), 2001

264-265
Bassorah, 2000

266
Double Bind (I), 1990
Silver prints mounted
on aluminum
100 x 150 cm (39⅜ x 59⅛ in.),
edition 3

268
French Pass, 1990
Silver print mounted
on aluminum
100 x 130 cm (39⅜ x 51⅛ in.),
edition 3

270-271
France, 1994

272-273
Leninakan, 1989

274-275
Les Trois Sœurs, 1996
Triptych: black and-white digital
prints mounted on aluminum
and framed
42 x 89 cm (16⅞ x 35⁄₁₆ in.)
overall, edition 3

280-281
Beirut, 1982

282-283
Scotland, 1990

284-285
Himalaya, 5600 meters, 1988

288 through 293
Iraq, 2001
3 color photographs mounted
on aluminum
120 x 180 cm (47¼ x 70⅞ in.)
each, edition 3

297
*A cause de l'élevage de
poussière,* 1991
Silver print
35 x 43 cm (13¾ x 16¹⁵⁄₁₆ in.),
unique

300
Self-portrait, 1999

Selected Bibliography & Exhibitions

Born in October 1949
Studied at the Université de Paris-Sorbonne, and the Ecole des Hautes-
 Etudes, Paris
Worked in publishing until 1980
Currently lives and works in Paris

ONE-ARTIST EXHIBITIONS

1984

Institut Français d'Architecture, Paris, France. *Beyrouth, Photographies*. Traveled. Artist's book.

Edelmann, Frederic. "Beyrouth photographies: Stades de la destruction." *Le Monde* (Paris), April 19, 1984, p. 13.

Jeffrey, Ian. "Sophie Ristelhueber, Beirut." *Creative Camera* (London), no. 239, November 1984, p. 1609.

1985

Blue Sky Gallery, Portland, Oregon. *Beirut, Photographs*.

1989–90

Galerie Joost Declerq, Ghent, Belgium. *Vulaines*.

1992

Le Magasin, Centre National d'Art Contemporain de Grenoble (France). *Fait*. Artist's book.

Guerrin, Michel. "Les obsessions de Sophie Ristelhueber." *Le Monde* (Paris), September 27, 1992, p. 14.

———. "Scars Across the Face of the Earth." *Manchester Guardian Weekly*, November 1, 1992.

1993

Galerie Joost Declercq, Ghent, Belgium. *Fait*.

Lambrecht, Luk. "Sophie Ristelhueber: Joost Declercq." *Flash Art* (International Edition), vol. XXVI, no. 169, March/April 1993, p. 94.

Imperial War Museum, London, England. *Aftermath*. Artist's book.

Walker, Ian. "Sophie Ristelhueber." *Untitled* (London), Spring 1993, p. 14.

1994

Centraal Museum, Utrecht, The Netherlands. *Every One*. Traveled.

Leguillon, Pierre. "Cicatrices." *Le Journal des Arts* (Paris), no. 9, December 1994, p. 16.

Obala Art Center, Sarajevo, Bosnia-and-Herzegovina. *Posljedice-Aftermath*.

1995

Cabinet des Estampes du Musée d'art et d'histoire, Geneva, Switzerland. *Sophie Ristelhueber: Les Barricades mystérieuses II*. Artist's book.

Bovier, Lionel. "Sophie Ristelhueber saute la barricade." *La Tribune de Genève*, November 25, 1995, p. 39.

1996

Galerie Blancpain-Stepczynski, Geneva, Switzerland. *Vulaines 1989–1995*.

1997

Galerie Arlogos, Nantes, France. *La Campagne*.

1998

Albright-Knox Art Gallery, Buffalo, New York. *Sophie Ristelhueber: Fait*. Traveled. Brochure.

Huntington, Richard. "The Albright-Knox Art Gallery: Sophie Ristelhueber." *Art New England* (Boston), vol. 19, no. 5, August/September 1998, p. 61

1999

The Power Plant, Contemporary Art Gallery, Toronto, Canada. *Sophie Ristelhueber*.

Hume, Christopher. "Of Beauty, War... and Ambivalence." *Toronto Star*, February 27, 1999.

Galerie Arlogos, Paris, France. *Autoportrait*.

Collard, Jean-Max. "Voir là-bas si j'y suis." *Les Inrockuptibles* (Paris), no. 211, September 1999, p. 70.

2000

Hôtel des Arts, Centre Méditerranéen d'Art, Toulon, France. *La Liste*. Catalogue and artist's book.

Sarano, Florence. "Le territoire et la liste." *Parpaings* (Paris), no. 13, May 2000, p 26.

Fonds Régional d'Art Contemporain Basse-Normandie, Caen, France. *L'air est à tout le monde (II)*.

2001

Galerie Blancpain-Stepczynski, Geneva, Switzerland. *Dead Set*.

Menz, Marguerite. "Sophie Ristehueber." *Kunst-Bulletin* (Zurich), no. 5, June 2001, p. 41.

GROUP EXHIBITIONS

1980

P.S.1, New York, New York. *Photo politic documents on minorities.*
Brochure.

1981

Musée National d'Art Moderne, Centre Georges Pompidou, Paris,
France. *Intérieurs.* Traveled. Catalogue and artist's book.

Doisneau, Robert. "La construction du bonheur." *Le Monde* (Paris),
June 23, 1981, p. 31.

1982

Musée d'Art Moderne de la Ville de Paris (France). *12e Biennale de
Paris.* Catalogue.

1985

Palais de Tokyo, Paris, France. *Paysages–Photographies, travaux en
cours de la Mission photographique de la DATAR.* Catalogue.

1986

P.P.O.W Gallery, New York, New York. *Dissolution.*

1987

Cleveland Museum of Art, Cleveland, Ohio. *Contemporary French
Landscape Photography.*

University of London (England), Goldsmith's College. *City Lights.*

Jeffrey, Ian. "City Lights noted." *Creative Camera* (London), no. 5,
1987, pp, 10–32.

1988

Houston Center for Photography, Houston, Texas. *Beyond the Image.*

1990

Galerie Verney-Carron, Villeurbanne, France. *Dhaulagiri.*

Chapelle des Arques, Lot, France. *Mémoires du Lot.* Artist's book.

1993

The 45th Venice Biennale, Venice, Italy. *Trésors de voyage.*
Catalogue.

1994

Munich Order Center, Munich, Germany. *Europa 94: Junge Europäis-
che Kunst in München.* Catalogue.

1995

Victoria & Albert Museum, London, England. *Warworks: Women, Pho-
tography and the Art of War.* Catalogue.

Williams, Val. "Prints of Darkness." *The Guardian* (London), January 1, 1995, pp. 6–7.

Palais des Nations, United Nations Headquarters, Geneva, Switzerland. *Dialogues of Peace*. Catalogue.

1996

John Hansard Gallery, University of Southampton, London, England. *Desert*. Catalogue.

MUKHA, Antwerp, Belgium. *Macht/Onmacht*. Catalogue.

The Museum of Modern Art, New York, New York. *New Photography 12. Richard Billingham, Thomas Demand, Osamu Kanemura, Sophie Ristelhueber, Georgina Starr, Wolfgang Tillmans*.

Musée National d'Art Moderne, Centre Georges Pompidou, Paris, France. *Face à l'Histoire 1933–1996: L'Artiste moderne devant l'événement historique*. Catalogue.

Béret, Chantal. "Le corps du monde." *Le Magazine du Centre* (Paris), Centre Georges Pompidou, November-December 1996, p. 16.

1997

Fonds Régional d'Art Contemporain, Corte, Corsica. *Géographiques, territoires vécus, territoires voulus, territoires figurés*. Catalogue.

IInd Johannesburg Biennale, Johannesburg, South Africa. *Trade Routes: History and Geography*. Catalogue.

P.S.1, New York, New York. *Heaven: Private View*.

1998

Fundació La Caixa, Barcelona, Spain. *Mirages, From Post-Photography to Cyberspace*.

WHO Headquarters, Geneva, Switzerland. *The Edge of Awareness*. Traveled. Catalogue.

Guggenheim Museum (Soho), New York, New York. *Premises: Invested Spaces in Visual Arts, Architecture & Design from France, 1958–98*. Catalogue.

1999

The Liverpool Biennial of Contemporary Art, Liverpool, England. *Trace/1st Liverpool Biennial of International Contemporary Art*. Catalogue.

2000

Musée National d'Art Moderne, Centre Georges Pompidou, Paris, France. *Une Histoire matérielle*. Catalogue.

Koldo Mitxelena Kulturunea, San Sebastián, Spain. *Erresistentziak= Résistance*. Catalogue.

2001

Galerie Les Filles du Calvaire, Paris, France. *Le Paysage comme Babel*. Catalogue.

Camden Arts Centre, London.

By the artist

Beyrouth, Photographies. Paris: Editions Hazan, 1984

Beirut, Photographs. London: Thames and Hudson, 1984

Mémoires du Lot (edition of 350), 1990

Fait. Paris: Editions Hazan, 1992

Aftermath. London: Thames and Hudson, 1992

Every One (limited edition). Paris, 1994

Sophie Ristelhueber, Les barricades mystérieuses II. Geneva: Cabinet des Estampes, 1995

La Liste. Toulon: Hôtel des Arts, Centre Méditerranéen d'Art, 2000

About the artist

Mission Photographique de la DATAR, *Paysages Photographies en France les années quatre-vingt*. Paris: Editions Hazan, 1989

Sans, Jérôme. *Sophie Ristelhueber: Field Work*. Caen, France: Fonds Régional d'Art contemporain de Basse-Normandie, 1995

Walker, Ian. "Desert Stories or Faith in Facts." Martin Lister (ed.), *The Photographic Image in Digital Culture*. London and New York: Routledge, 1995

Hindry, Ann. *Sophie Ristelhueber*. Paris: Editions Hazan, 1998

Mayer, Marc. *Sophie Ristelhueber*. London: Phaidon (forthcoming)

Taped Interviews

Domino, Christophe. *Journal de la création*. Paris: La 5ème (television), 1996

Hindry, Ann. *L'Art et la Guerre*. Paris: Centre Georges Pompidou, 1997

Cayo, Elsa. *Art et Histoire*. Paris: Arte (television), 1998

Acknowledgments

It has been a privilege to work with Sophie Ristelhueber on this publication, which accompanies a major exhibition and the first survey of her career. This intimate volume, with its unusual format and conception, joins other books created by the artist—a medium for which she is highly regarded, and of which few examples still remain available. I am especially indebted to Didier Larnac of Galerie Arlogos, Paris, for his assistance and unparalleled commitment to the artist, Marc Mayer, Director of the Power Plant, Toronto, and the lenders to the exhibition. The MFA is also grateful to Etant Donnés, the French-American Fund for Contemporary Art, for its generous support of this project.

At the MFA, the book benefited from the efforts of Mark Polizzotti, Director of MFA Publications, and Dacey Sartor, Managing Editor; as well as of Esther Adler, Department Assistant, and Anja Chavez, Assistant Curator, in the Department of Contemporary Art. Most of all, I would like to thank Malcolm Rogers, Ann and Graham Gund Director, and Katie Getchell, Deputy Director for Curatorial Affairs, for their encouragement of innovations such as this one.

Finally, I would like to express my appreciation to Sophie Ristelhueber herself. She has given us far more than her poignant and extraordinary details of the world, for which we are enormously grateful.

C.B., May 2001

MFA PUBLICATIONS
a division of the Museum of Fine Arts, Boston
295 Huntington Avenue
Boston, Massachusetts 02115

Published in conjunction with the exhibition *Sophie Ristelhueber: Details of the World*, organized by the Museum of Fine Arts, Boston, from September 26, 2001, to January 21, 2002.

Generous support for this publication was provided by Etant Donnés, The French-American Fund for Contemporary Art

etant
donnes

For a complete listing of MFA Publications, please contact the publisher at the above address, or call 617 369 4367.

ISBN 0-87846-625-8
Library of Congress Control Number: 2001088639

Book conceived and designed by Sophie Ristelhueber

Available through D.A.P. / Distributed Art Publishers
155 Sixth Avenue, 2nd floor
New York, New York 10013
Tel.: 212 627 1999 · Fax: 212 627 9484

FIRST EDITION
Printed and bound in Singapore